The Art of

PREGNANCY PHOTOGRAPHY

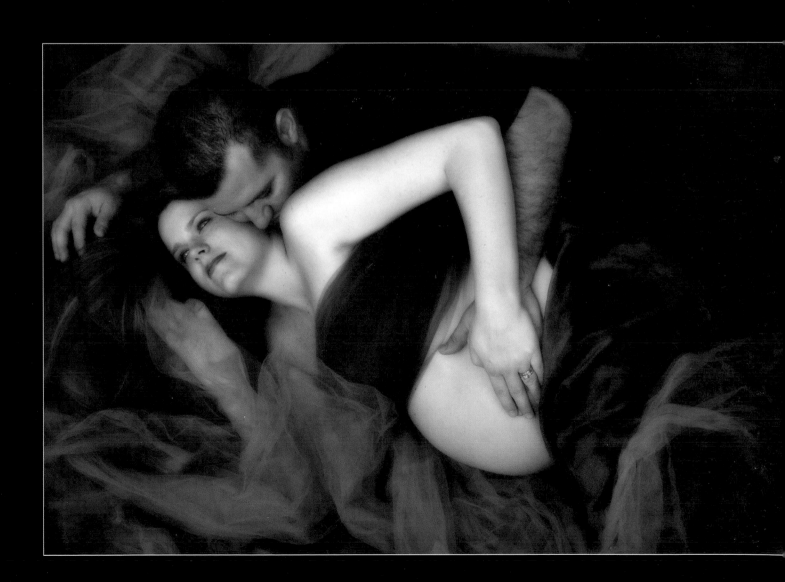

JENNIFER GEORGE

Amherst Media, Inc. ■ Buffalo, NY

Published by:
Amherst Media, Inc.
P.O. Box 586
Buffalo, N.Y. 14226
Fax: 716-874-4508
www.AmherstMedia.com

Publisher: Craig Alesse
Senior Editor/Production Manager: Michelle Perkins
Assistant Editor: Barbara A. Lynch-Johnt
Editorial Assistant: John S. Loder

ISBN-13: 978-1-58428-218-1
Library of Congress Control Number: 2007926870
Printed in Korea.
10 9 8 7 6 5 4 3 2 1

CONTENTS

ABOUT THE AUTHOR

Photo by Darton Drake.

"At last, we have someone who creates breathtaking new images."—Tony Corbell

Jennifer George owns and operates Jennifer George Photography in San Diego, CA. She received her Masters degree from the Professional Photographers of America (PPA) in only three years' time and received her Photographic Craftsman degree the next year. After winning the California Photographer of the Year Award in 2001 from Professional Photographers of California she was able to travel across the state, sharing her award-winning portrait style and inspiring others to tap into their creativity. Jennifer received the Grand Premiere and First Place Awards at the Wedding and Portrait Photographers International (WPPI) print competition in 2003, then won the gold-level Photographer of the Year Award from PPA in 2005. She taught at the PPA Women in Photography convention in 2004 and spoke and taught at the annual WPPI convention on three separate occasions. Six of her works have been selected for National Loan Exhibition by PPA. Additionally, two of her prints were selected for the PPA display in Seoul, Korea, in 2005.

Jennifer has quickly gained a reputation for her innovative, heartfelt style and is passionate about reaching out to other photographers. She is a frequent guest lecturer at colleges, universities, photography affiliate organizations, and workshops in the United States and abroad.

The Art of Pregnancy Photography is Jennifer's second publication. She joined with other photographers to produce *A Mother's Touch* (Zondervan Publishing House [a division of HarperCollins Publishers] 1998), a book of photos and quotes from women on motherhood. Her photos and statements have appeared in *Professional Photographer* magazine, *The Portrait Photographer's Guide to Posing* (Bill Hurter; Amherst Media, 2004), *The Portrait Photographer's Handbook* (Bill Hurter; Amherst Media, 2005), and *Digital Photography for Children's and Family Portraiture* (2nd ed., Kathleen Hawkins; Amherst Media, 2008).

In an interview in *The Portrait Photographer's Guide to Posing,* Jennifer said, "I push myself creatively in order to create things my clients have never seen before." Jennifer also explains that her signature style includes the use of body makeup and skin tone changes because she is enthralled with the idea that who we are is much more than skin deep, and it doesn't matter what color you are on the outside. She says, "It is the soul underneath that is so beautiful."

Jennifer teaches other photographers to cultivate the technical skills they need to enhance their images. However, she strongly feels that photography has moved away from a technical skill and into the realm of accepted creative art. She says, "Albert Einstein said that creativity is more important than knowledge. All the knowledge in the world will never allow you to touch others with emotions and to touch their soul—that's the role of creativity."

INTRODUCTION

Are you looking for a new genre that will allow you to increase your studio's revenue? Would you like to secure the job of producing a family's portrait work for the next eighteen to twenty-five years? Do you want to take advantage of an emerging market trend in portrait photography? If you answered yes to any of these questions, you should consider adding maternity photography to your studio's repertoire.

Images of pregnant women were once taboo in our culture, but in 1991 when Demi Moore posed for the cover of *Vanity Fair* magazine while seven months pregnant, a shift occurred in how our culture views pregnant women. That single photograph opened the doors for society to acknowledge and celebrate the beauty of the pregnant body.

The demand for images of women who are pregnant has never been greater. Magazines are filled with photos of celebrities proudly showing off their pregnant figures, and women everywhere want to document their beauty during pregnancy. This is a relatively new and highly profitable market for portrait photographers. Portraits of pregnant women have become elegant, sensual, and intimate. The relationship you build with your clients during the maternity session can also lead to future portrait sessions with the women and their families—and that's good news for the professional wedding and portrait photographer.

Historically, a wedding photographer would book a couple's engagement/wedding photo session; a portrait photographer would take newborn, early childhood, and family portraits; then another photographer would take the children's school and senior portraits. Even if you were a wedding and portrait photographer and recorded all of those events in a client's life, there was little more you could do. However, by adding maternity photography to your studio's repertoire, you have another opportunity to strengthen your relationship with your clients, document an important milestone in their lives, and add value to your services. Imagine taking a new client from engagement to wedding photos, to maternity photos, to newborn photos, to children's photos, to family portraits, to senior portraits, and then to engagement photos—the full circle. The market is such that if you can produce a beautiful image of a pregnant woman, you will have that family's portrait work for the

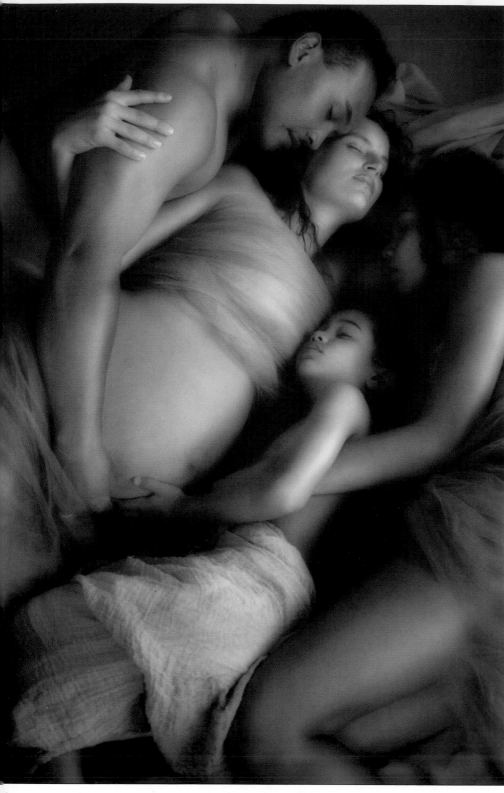

Left—There are times when all the elements come together in a split second and you have the opportunity to capture an amazing moment. This beautiful family was close and tender with each other; only slight refinements to the pose were required to compose the story. This image was created in the studio using window light. A black panel was used at camera left to deepen the shadows. The portrait was captured with a Fuji FinePix S2 Pro camera at $1/60$ second at f/4.0 with an ISO of 400. After the image was retouched in Photoshop, it was enhanced with the Nik Color Efex Pro 2.0 Midnight filter. Facing page—Creating a beautiful image is simple when you understand light. Creating this image required only a large window, some fabric, and directing the subjects into a natural pose. The couple was posed atop several backdrops and fabric placed on the floor. The light came from a large sliding glass door in the living room of their home. This image was captured on a Fuji FinePix S3 Pro digital camera with a Tamron SPAF Aspherical XR Di LD 28–75mm f/2.8 lens. The ISO was 400, and a shutter speed of $1/90$ second and aperture of f/4.8 were selected. The image was slightly retouched in Photoshop and then enhanced with Nik's Midnight filter.

next fifteen years—at a minimum. More and more photographers are seeing maternity photography as a natural evolution for wedding photographers who want to continue the relationship they have already established with their clients.

Maternity sessions can result in exquisite images. Capturing the woman at this remarkable stage in her life sets this type of portrait photography apart

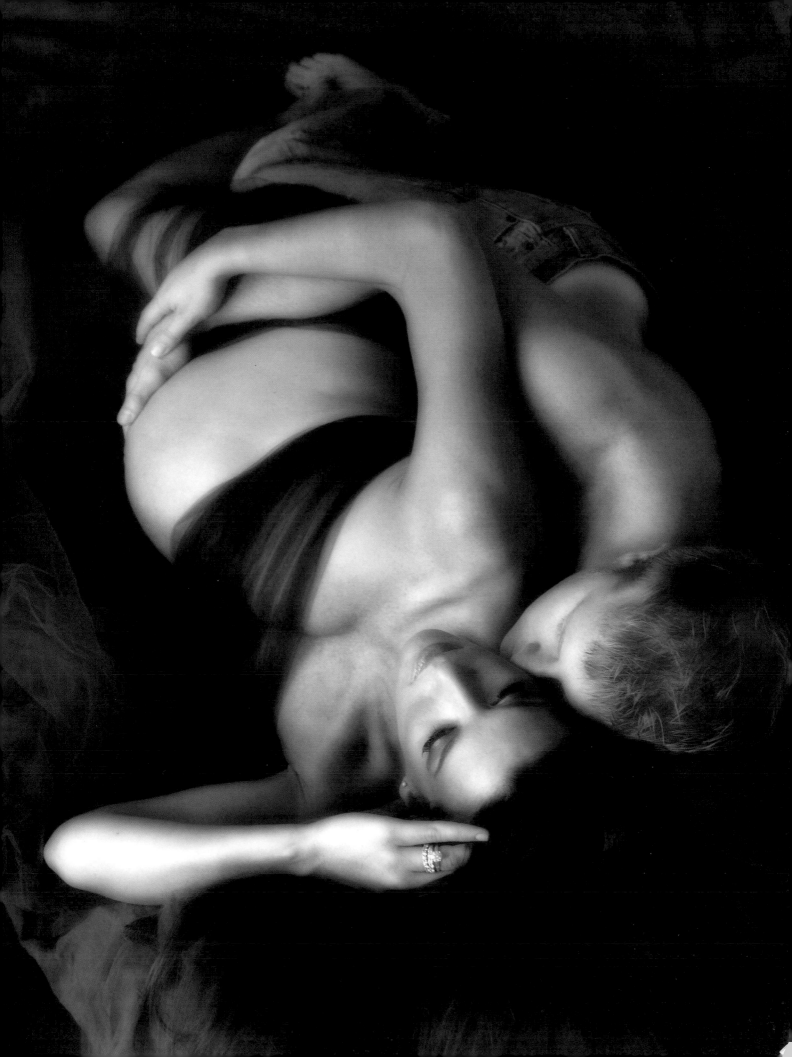

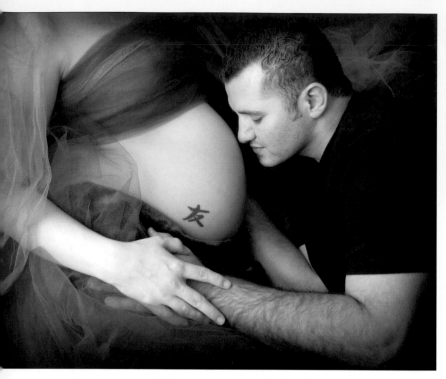

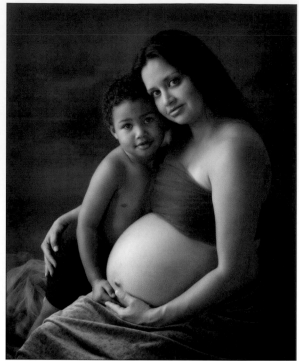

from the rest. This is an opportunity for the portrait photographer to utilize all of their technical and artistic skills to create dramatic to luxurious images, depending on the client's personality and preference. None of these sessions or images will ever be called "typical."

The time is finally right for maternity portraiture. Photographers can use Adobe Photoshop and a host of Photoshop-compatible plug-ins to retouch stretch marks and blemishes quickly and easily and achieve greater creative and artistic freedom. From slimming areas of a subject to the fantasy approach of placing the newborn baby in the image of the pregnant mother, to converting color images to black & white, anything is possible!

ABOUT THIS BOOK

The Art of Pregnancy Photography was written for the intermediate to advanced photographer who wants to add pregnancy photography to his or her repertoire. While many "how-to" books teach the basic technical information required to conduct a photo session, this book explores maternity photography from a conceptual and artistic point of view. Readers are encouraged to think about the location of the session, what props and fabrics will best enhance the images, how to pose the subject and create an effective composition, how to create dimension and flatter the subject's form with light, and how to apply creative effects to the portraits to take your artistry to the next level. The book also looks closely at the importance of developing your relationship with your subject. It is essential that photographers understand that helping the pregnant woman relax and feel beautiful is just as important to a successful shoot as setting up flattering lighting. Each chapter of the book will explore the elements that must be considered to conduct an extraordinary, artistic, and rewarding maternity portrait session.

Left—It is a privilege for photographers to witness and capture tender moments like this. Having the right tools and knowledge makes all the difference. This couple was lying by their bedroom window in an area propped with fabrics. Placing them in the right light produced the form and depth seen in the portrait. The image was captured on a Fuji FinePix S3 Pro camera with a Tamron 28–74mm f/2.8 lens and settings of f/4.8 and 1/90 second at an ISO setting of 400. The image was converted to black & white with the Kubota Artistic Actions Vol. Two New B&W action, and the edges were darkened with Kubota's Edge Burner action. (The actions are available at www.KubotaImageTools.com.) **Right**—Working with children can be rewarding when you understand what they respond to and don't respond to. This active little boy was more willing to pose with the right directions. This window light image was captured with a Nikon D2x and Tamron 28–75mm f/2.8 lens. The exposure was captured at an ISO of 400, a shutter speed of 1/125, and an aperture of f/5.3. After the image was retouched in Photoshop, it was enhanced with Nik's Midnight filter.

1. PREPARING FOR THE SESSION

Conducting a pre-session consultation will allow you to develop a rapport with your client and make key decisions about how the portrait session will unfold. This is the time to select a location for the portrait session, set a date and time, discuss clothing and makeup options, and share a few success stories from your previous pregnancy sessions. This is the perfect time to assure your client that a maternity session can be more than a means to capturing a moment in time—it can also be an opportunity to create artful images that depict your client not as clumsy and large but graceful and beautiful. When a woman contacts you to book a session, offer to conduct the consultation in her home, as this may be more convenient—and more comfortable—for the client.

LOCATION

Most photographers don't put a great deal of thought into selecting a location for their client's portrait session, but in pregnancy photography, choosing the location can be one of the most important decisions the photographer and client make.

Home vs. Studio. Most portrait clients come to the studio to be photographed. However, for a maternity client, the best location for the session will likely be her home. In maternity portraiture, the subject's comfort is more critical than it is with any other demographic. Pregnancy causes many changes in a woman's body. Not only does the abdomen become enlarged, shifting the woman's center of gravity to her middle, but she may also be coping with an aching back and knees from carrying the extra weight, difficulty breathing from the growing baby pushing on her chest cavity, and hip pain from the stretching of ligaments as her delivery date approaches.

Working in your subject's home will save her the trouble of having to travel. She will also benefit from having more clothing choices at hand and the ability to change in the comfort of her own bedroom or bathroom.

There are many advantages for the photographer in conducting a session at the subject's home as well. Window lighting is one of the best lighting scenarios for portraiture; the light is full, soft, and luminous—and chances are, your client's home will offer a variety of effective window light options. Also,

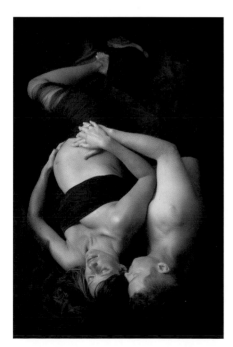

Simple lighting and sumptuous fabrics can be used to create heirloom images in the subjects' home or in the studio.

it may be difficult for a pregnant woman nearing the end of her third trimester to move around, and having a bed to photograph her on can offer relief for her aching back and hip joints. (Note that most master bedrooms have the largest bed in the home and a large window to work with.) As the subject relaxes and you dole out praise, you will see a look of calm and serenity come over her.

If you're conducting the consultation in your client's home, you'll want to determine which rooms will provide the best window light opportunities, whether it's okay to move the furniture, and any other issues that will impact the session. You can also sell your client on the above-mentioned benefits of conducting the session in her home.

On the other hand, there will be times when the studio is the best choice for the session. In some cases, the portraits are being created as a gift for the baby's father, and the woman may have trouble scheduling a session when her significant other is not at home. The studio will also likely be the best choice for the session if the client desires high key or low key images.

Shooting from a higher perspective in the subjects' bedroom allowed for the beautiful presentation shown in the final image.

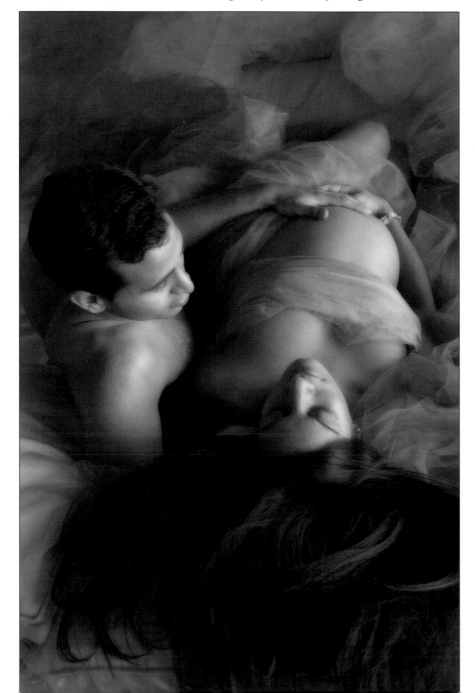

This pair of images shows once again how a few simple tools and props plus great window light can be used to your advantage when creating an image in your subjects' home.

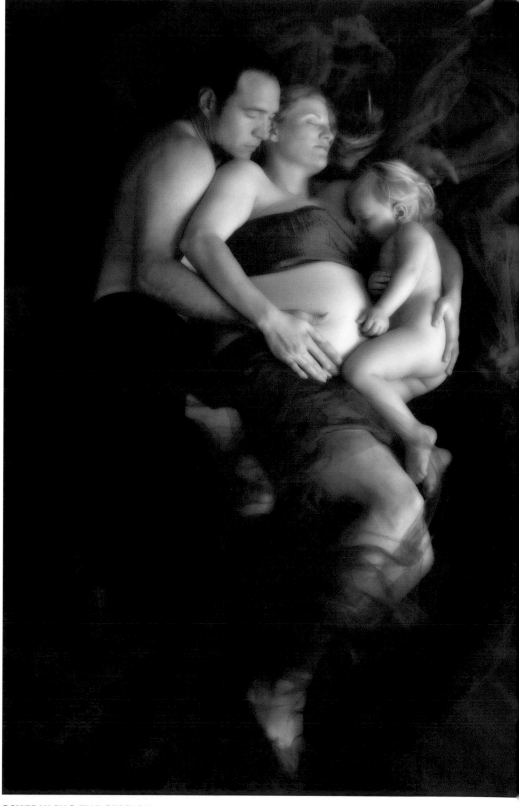

SCHEDULING THE SESSION

Don't forget to determine the client's due date, and try to book the session as close to that date as possible. Many photographers feel that it is best to photograph the mother about midway through the eighth month. At this point in the pregnancy, the mother is still mobile and the abdomen is close

to its full size. For the mother carrying twins, the time for photographing the pregnancy will be toward the beginning of the third trimester, at about seven months. By this time, the mother of twins will already have a large midriff, and because many twins are born early, scheduling a session later in the trimester may mean missing the opportunity to capture the moment.

Booking the session for a time of day that best suits the mother's schedule is critical. Choose a time of day when the mother will be well rested, and make sure she has no other activities planned for the day of the shoot. If young children will be present during the session, it may be best to work in the morning before the toddler becomes tired. Suggest the mother eat a light snack before the session. Finally, realize that if she is bringing a baby, she may need to stop during the session for a feeding.

CLOTHING AND MAKEUP

During the consultation, you'll want to discuss the type of clothing and makeup that will yield the best portrait results. As the many images in this book show, my own approach is to drape and wrap the subject in beautiful fabrics rather than have her wear street clothes. To do this, the woman must wear a strapless bra (preferably one that is well matched to her skin tone). You might also consider providing tube tops in a variety of sizes; these can be beneficial in a pinch. The mother should wear low-cut, small underwear that can easily be covered with the fabric. Be sure to suggest that she wear loose clothing before the session, so as not to create lines or indentations on the skin. Street clothes, of course, are also an option for some clients.

Unless you are able to hire a makeup artist, the subject will have to apply her own makeup. It is recommended that all subjects wear makeup for their portrait session. Applying a thin layer of complexion-matching foundation will smooth out the pregnancy mask and blemishes from changing hormones. Eyebrow pencil will help keep the eyebrows from disappearing in the images and will help to give the face structure. A light coat of mascara is needed for eyelashes. Adding a little blush to the cheekbones gives form to the face, and lipstick will help keep the lips from vanishing in the portraits.

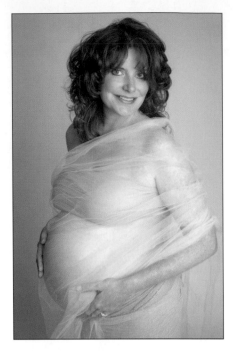

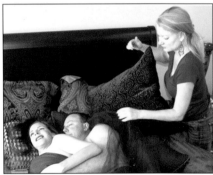

Top—The neutral clothing complemented this subject's coloring and keeps the eye on the focal point of the portrait. **Above and facing page**— A comfortable bed and rich, luxurious fabrics provided the perfect backdrop for this beautiful portrait.

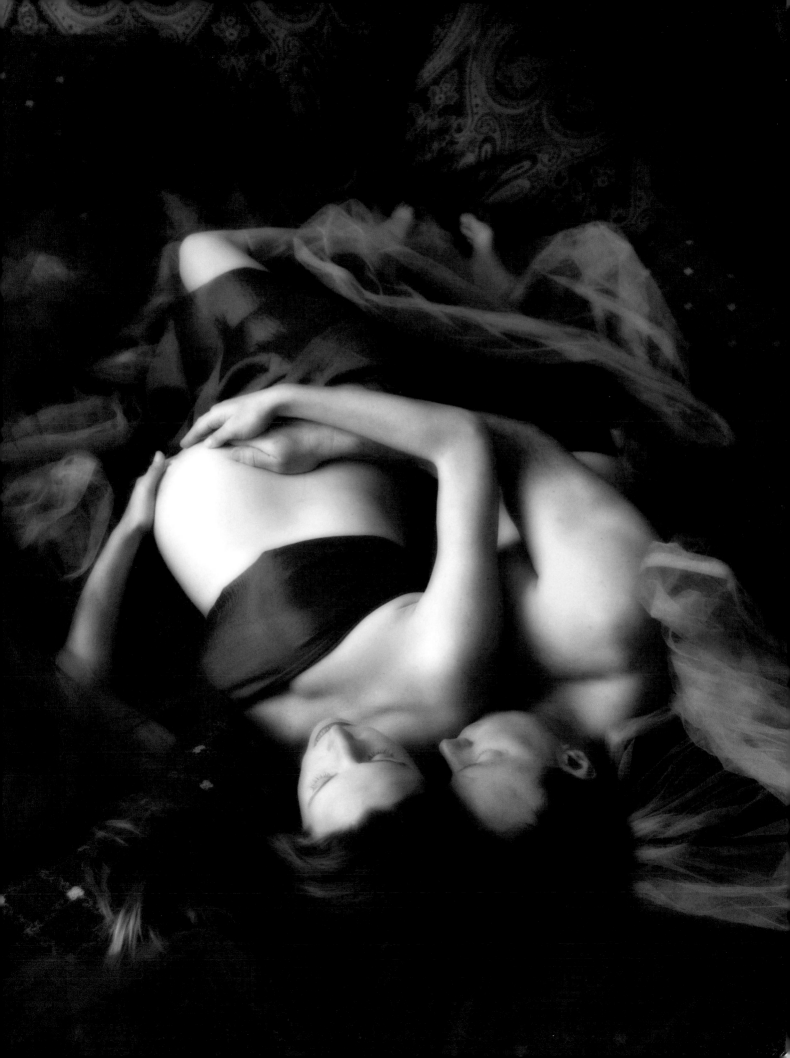

2. CONNECTING WITH YOUR CLIENTS

Ultimately, your success in creating truly great portraits will stem from your ability to establish a close connection with your clients. While this point may seem obvious, not all photographers put as much effort into the way they relate to people as they do to the technical aspects of their photography. In this chapter, we'll look at some strategies for making the client physically comfortable, building her enthusiasm for the session, working with other family members, and expressing your goals for the session.

BUILDING THE RELATIONSHIP

In maternity photography, ensuring that the client is comfortable and relaxed is critical. Starting with the pre-session consultation, your goal is to establish a trusting relationship with your subject while getting the critical information you need to ensure the session meets her needs. Ask questions about the outcome she wants to achieve in the session, but also be sure to ask about her life. Determine why she is interested in having this time in her life photographed. Share stories about other maternity clients you have photographed. Gather information that will help you ensure the best location for the setting. As you do so, determine when the baby is due and whether there are any siblings—if so, find out whether the sibling or other children are excited or upset about the new addition.

Ensuring your client's physical comfort is an essential component in building your relationship. If your pregnant subject is uncomfortable, her ability to relax and enjoy the session will be hampered. Being mindful of the physical changes that pregnancy brings will be tremendously helpful in preparing you to ensure your subject's comfort during the session. For instance, a mother carrying a nearly full-term baby will find herself uncomfortably warm most of the time. Anticipating the problem and asking her if the room temperature needs to be changed or lights should be moved can make a world of difference in the quality of the session.

SHARE YOUR VISION

In the beginning of the session, express your goals and share your ideas. Help them get excited about your vision. Explaining the lighting setup, the direc-

▶ **CLIENT TESTIMONIAL**
"I love my pregnancy pictures because they give me a chance to look back at a special time in my life, waiting in anticipation, not knowing the face or the personality of that little person to be born."
—Iris H.

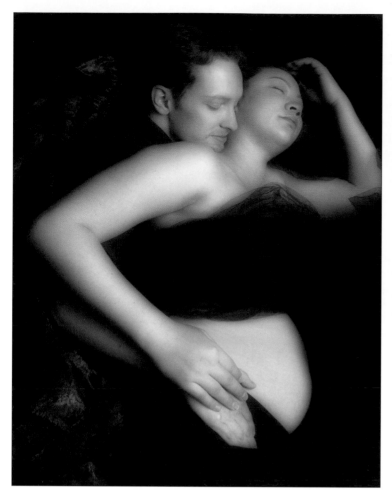

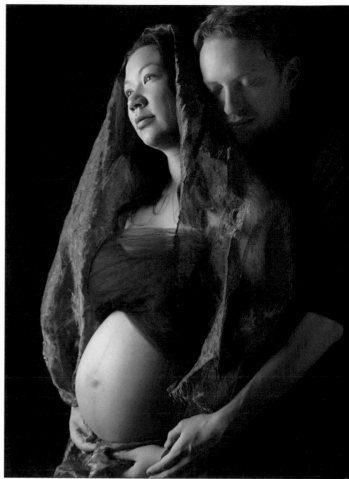

A good way to instruct a couple or group is to set the anchor person in place first, then role-play the second position. With a group, this is a good way for the other subjects to see what you are trying to achieve before they try to get into place.

tion of the light, and where the subject should stand, sit, or lie down will help to build their trust in you. Giving a brief overview contributes to their understanding and support for your idea.

BE ENCOURAGING

A woman in the late stages of her pregnancy will need lots of encouragement. From the moment you first meet the subject, take note of the positive aspects of her appearance and pay her compliments. This will help build her confidence, which, in turn, will help you in posing her and composing the image later in the session. For example, if your subject has bright blue eyes, compose an image that brings the viewer's attention to her face. A woman with a tiny figure can do several poses standing, while one with extra weight may have to do most lying down.

When it's time to move on to the posing, there are a variety of ways to ensure a successful, flattering pose. The various strategies will be covered in detail below.

Show and Tell. To evoke the emotion you are looking for, talk to your subjects about your creative vision for the images. Like a movie director, you will have to prompt the subject to express the emotion you want to show. Calmly give the woman several verbal cues regarding the emotion, all the while watching for small nuances that will help to keep the emotion real. If

you are telling a mother to relax and be serene, for instance, make sure that her shoulders are not held too high or rigid.

When you direct the subject, physically show them where and how to pose. Step back and let them try your pose. Once you walk back to the camera area, refine the pose verbally and by demonstrating with your hands.

Quiet Encouragement. With pregnancy photography, the goal is to depict the mother's beauty and nurturing qualities. To evoke this mood, you will want to maintain a calm and quiet demeanor. Then, simply connect with your client using your tone of voice and posture to elicit the expression you want. By keeping the tone of the session low key, the subject can engage in her innermost thoughts.

Candid Moments. Some subjects may almost intuitively present themselves in a flattering way. When the moment is right, simply capture a series of images of the mom being "in the moment."

Whatever your approach, remember that your client cannot see what you are seeing through the camera. Be sure to describe the beautiful scene, comment on how flattering the lighting is, and express how well the fabric enhances her skin tone. Paint a picture with your words, all the while instilling confidence.

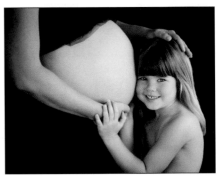

These candid images show a tender moment between the pregnant mom and her child.

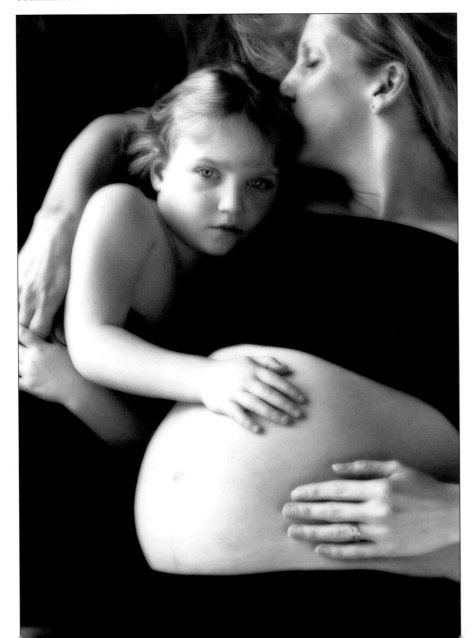

The client had a very clear vision of the images she wanted, and after discussing her concept and learning about her family situation, the client's living room was selected as the best location for the session. A thin diffusion fabric clamped over the window provided privacy and created soft window light similar to the light quality output by a softbox. To soften the lines, add interest, and create a more modest image, brown and gold tulle was wrapped around the woman. The finished image was one not envisioned by the client but developed by moving around the client during the session.

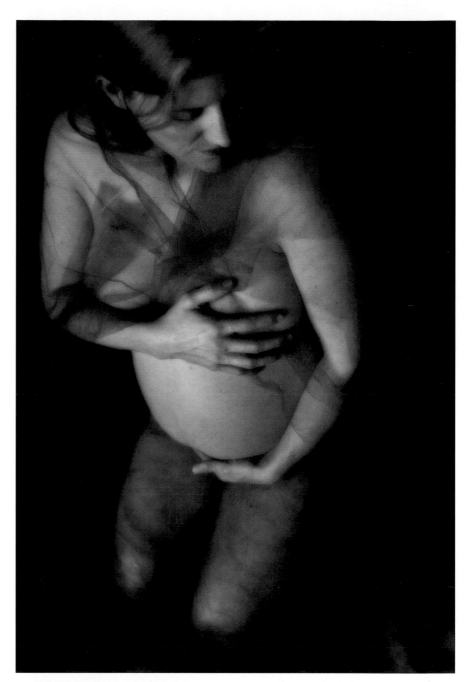

PHOTOGRAPHING NUDE SUBJECTS

Working with a nude subject presents several challenges for all photographers, male or female. Before beginning the session, make sure you've cultivated a comfortable relationship with the subject. Also, be sure that you fully understand what she wants to achieve during the session and what she is comfortable with. Usually it is the client who wants the nude images, and so she will be fairly comfortable with posing.

Next, you will need to determine the best location for the session. Keep in mind that nude portraits taken at the woman's home will improve her comfort level—and yours as well. As discussed earlier, the comfort of the woman is imperative to the quality of the finished images. The emotion and realism depicted in a nude portrait is directly related to the subject's peace of mind.

Working with an Assistant. Having an assistant on hand when working with nude subjects is a good idea for female photographers, and for the male photographer, a female assistant is a necessity. Your assistant can hold reflectors, drape fabric, and even help dress the subject.

Use Verbal Directions. It is important to use verbal instructions and not touch the subject to direct the pose. For both male and female photographers, keep a appropriate distance from the subject, relying only on verbal directions. Having a strong foundation of different poses that work in the nude will move the session along and relax the subject.

Watch the Details. While capturing the image, be sure to keep an eye on the details. The smallest mistake in positioning the subject can ruin the abil-

Left—With the aid of an assistant, this "nude" maternity image was created at the subject's home. **Below**—Never touch a nude subject when helping them pose. Demonstrating the pose or simply providing verbal instructions is a more professional option.

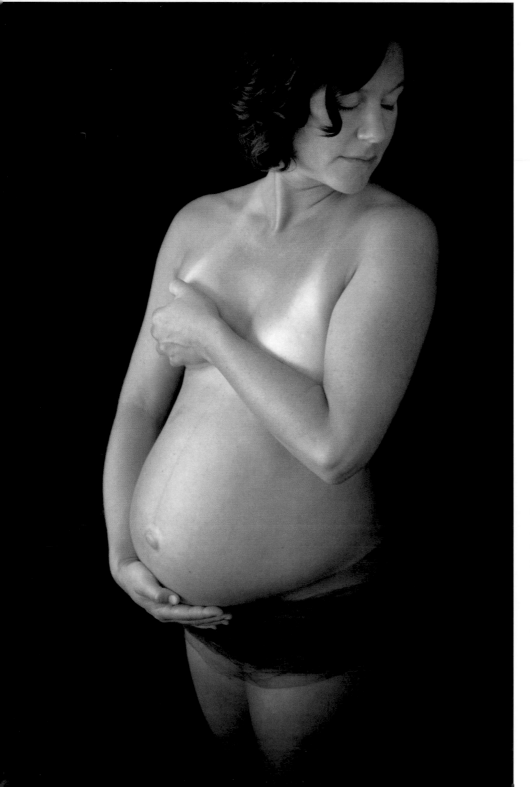

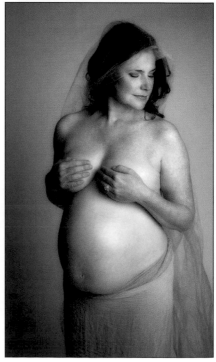

Top—Asking the young sibling, "Can you hear the baby?" and having them listen to Mom's tummy can produce a whimsical expression. **Bottom**—Terrible twos are always difficult, and sometimes the only thing you can do is to reign the toddler in with the parent's help.

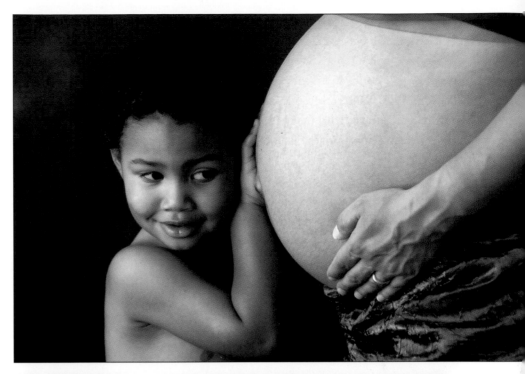

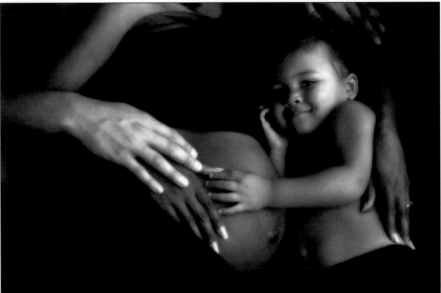

ity to use the image. Take special care to ensure that areas of the body you do not wish to show are covered by the hands or the position of the legs. Consider using fabrics of varying weights and textures—or perhaps a robe. These options can provide the required coverage and a dose of texture in the image.

CONNECTING WITH CHILDREN

Increasing Your Odds. When your client's children are to take part in a portrait session, there are a few tips you can use to increase your odds of creating great, salable images. At your first opportunity, get down to their eye level, introduce yourself, and talk directly to them. Start off with happy, friendly, but very calm conversation. Your behavior will set the tone of the ses-

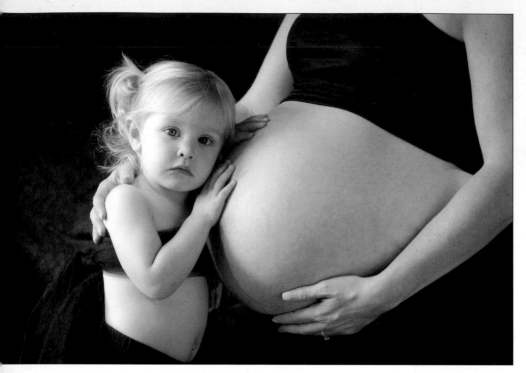

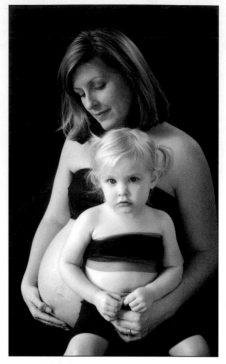

sion for the child. Next, let the child watch you set up the studio equipment while being held in the arms of a parent.

When it's time to begin photographing a mother-and-child portrait, remember that keeping the child close to mom will foster the feeling of protection. Step back and let the child interact with Mom naturally, while you quietly capture those moments.

Eliciting Expressions. Capturing great expressions when photographing children takes practice and patience. We all should be able to hold a squeaky toy, tell a joke, or just act silly to get a big smile. The hard part is when you want something thoughtful or just plain adorable.

Sometimes the best images happen when you stay calm, just let the subjects be themselves, and capture the moment. Working in the home can be advantageous when small children are a part of the session—babies and toddlers are always more at ease in the familiar surroundings of their homes. Working on their turf can allow you to capture calm, sweet, and tranquil expressions.

Whether it's fate, the temperament of the child, the relationship between the child and parent, or the baby is sick or teething or just not feeling well, there will be times when nothing you try will help you to get the child to cooperate and reward you with great expressions. In those situations, be flexible—and if need be, stop the session and try it another time. It would be prudent, however, to hand the child off to the father for a few minutes while you quickly capture a few images of the mother by herself, as you may not get the chance again.

Left—Sometimes having the child touch or listen to their mom's tummy makes for a great, expressive image. The little girl in this portrait appears hesitant, not sure about all this, but wanting to be close to mom. **Right**—For the young sibling, Mom's pregnancy may not be the best time. In this image, the child's expression sends a clear message about her take on the pregnancy. Conversely, the mom's expression conveys her contented state of mind. **Facing page**—Keeping the child close to Mom and Dad will ensure a calm, secure child.

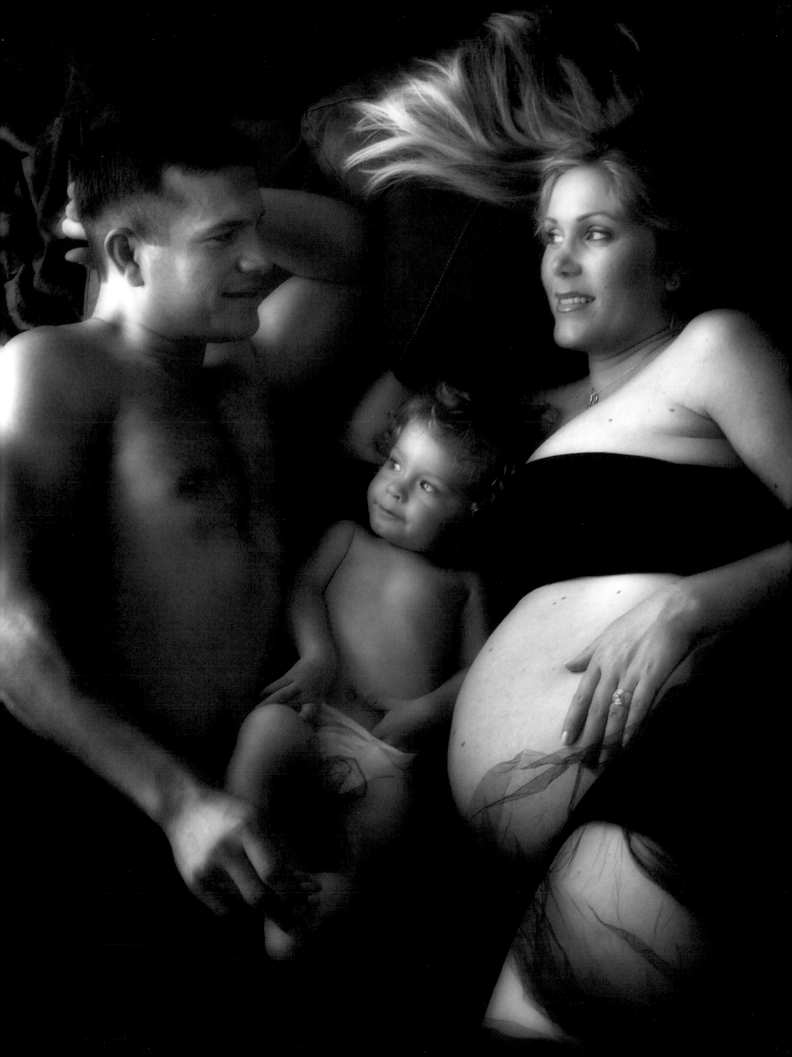

3. PROPS, FABRICS, AND BACKGROUNDS

Pregnancy is an important stage in the human experience, and it should be the goal of the photographer to do more than simply document this phase of the subject's life. It should be your goal to create portraits that express the subject's mood, her nurturing qualities, and the quiet anticipation

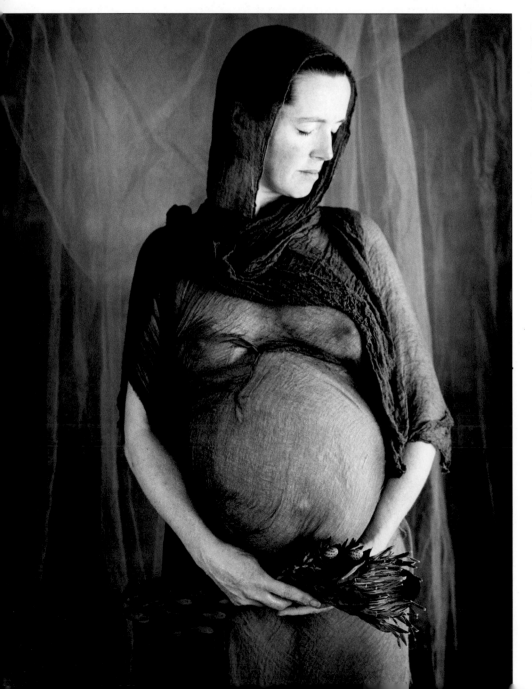

Left—It's easy to create romantic and fantasy images when incorporating beautiful, richly colored and textured fabrics in your portraits. **Above**—Flowers and fabrics are the simplest and most appropriate additions to maternity portraits. Keeping props simple allows the viewer to focus their attention on the focal point of the image—the radiant subject.

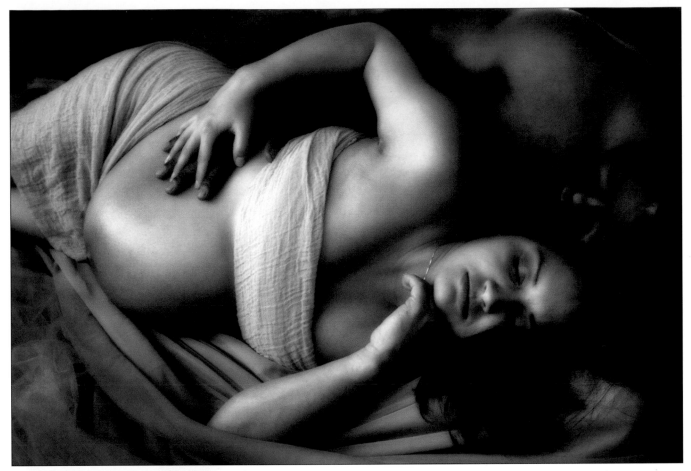

of the birth. The portraits should have a storytelling quality and should be free from objects that date the image.

In this chapter, we'll take a look at some props, fabrics, and backgrounds that work well for pregnancy portraiture and add interest in the portrait without detracting from the viewer's focus on the subject.

PROPS

Props have been used by photographers for over a century. Unfortunately, photographers can become so enamored with the overuse of props that the main objective of the image is lost. Props should always be used to enhance the image and should never distract the viewer's attention from the subject. Again, simple is better when adding any element to an image, and it is especially true when using props.

Flowers are one of the most suitable props for maternity portraits. They are associated with feminine beauty and also symbolize growth and new beginnings. Having several types and shades of silk flowers on hand is a quick and easy way to add interest in an image.

Antique furniture and other objects that hold sentimental value for the subject may also be considered, so long as the objects do not date the image. Keep in mind that any furniture incorporated in the portrait should be darker than the subject and should not reflect the light. A quick visual scan of the overall scene should help you to identify and remove any distracting elements.

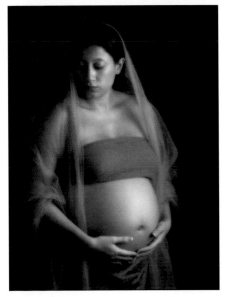

Top—Selecting fabrics that harmonized with the subjects' skin tones and arranging them for the clients to lie on provided a great base for the image. Next, a background with the same tones was added. These simple steps can add tremendous impact to the image. **Above**—Selecting fabrics in the same color family keep the viewer focused on the reflective, nurturing mood exhibited by the subject.

FABRICS

There are thousands of fabrics available today, but only those that are thin, lightweight, and have texture will work well as attire for your subject. Some of the most effective fabrics for draping over and around the human form are gauze, tulle, muslin, silk, crepe, stretch velvet, and chiffon. In the past, the color selection available for each of these fabric types was rather limited. Today, muslin is not just available in the traditional beige but in numerous colors too. For unique colors and textures in fabrics, look beyond the fabric stores and investigate upholstery shops. With the wide variety of fabrics available, your options are limited only by your imagination.

Gauze. In the right-hand image on the facing page, the mom was wrapped in moss green gauze, which harmonized beautifully with the background and flowers. The fabric was wrapped tightly around her to show off her small figure and the perfect shape of her midriff.

Tulle. If you plan to invest in only one type of fabric, tulle would be your best bet. Tulle is a soft, net-like material that is traditionally used for making wedding veils and dresses. It is also incredibly inexpensive and comes in a wide array of colors.

Because it is lightweight and thin, tulle is perfect for wrapping around the body. It can also be used to add dimension on the set. Randomly spread the tulle in uneven horizontal lines from the camera view. The tulle should create an undulating line to enhance the sense of depth in the image, as is shown in the left-hand image below.

Tulle can be used to drape the subject's body, but don't overlook the option of using it to add dimension in the overall image. The left image shows the effect of covering a bed in mounds of swirling fabrics. The right image shows how draping the fabric across the subject added interest and created a leading line that draws the viewer's gaze to the subject's face.

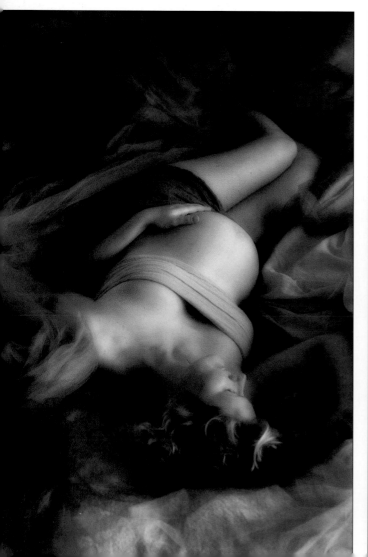

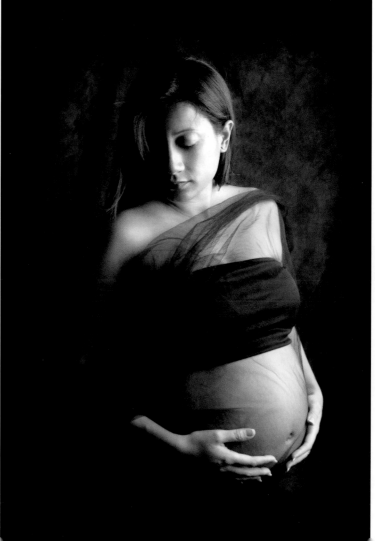

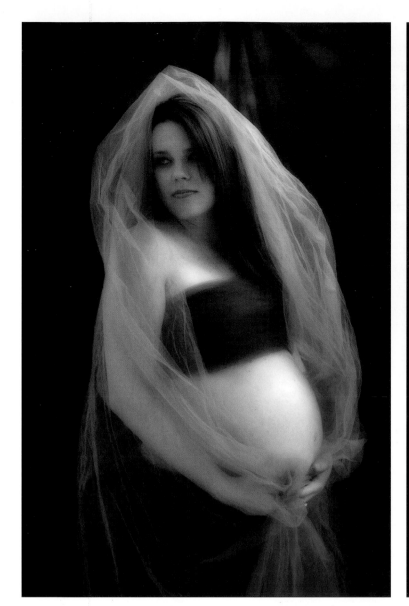
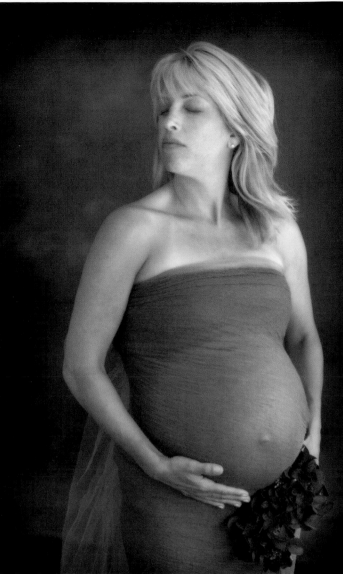

The poses selected for these subjects were identical, but the different fabrics used in the images create two very different moods in the portraits.

Tulle can also be used to cover or create transition points in an image. Placing tulle at the point where the background and floor meet, for example, can give a finished look to the image. Dark tulle can be used to form a natural vignette around the edges of the image area. With the subject lying down, use the tulle along all the image edges to draw the viewer's eye directly to the subject.

BACKGROUNDS

By layering traditional canvas or muslin backgrounds with an interesting, textured fabric clamped over the backdrop, you can create depth and interest in the portrait and create enhanced mood and dimensionality. Make sure that any fabrics to be added to the portrait complement the subject's hair and skin tones and harmonize with the subject's clothing and any props. Once the background fabrics are chosen, you can add supplementary fabrics of similar shades, draping them over the background and using them to vignette the subject.

Upholstery fabrics, many of which are patterned and/or textured, though too stiff and heavy for use in draping the client, are perfect for creating an interesting background. Jacquards and other fabrics in botanical prints can work well for maternity portraits. Alternatively, a 3x4-foot or larger throw blanket or rug can be used as an interesting background.

▶ **CLIENT TESTIMONIAL**
"The joy I felt within my soul for nine months was captured that day with a photograph, and it will stay with me forever."
—Shawna M.

Top and bottom—An advantage to working in the client's home is that their personal belongings are at hand and can be easily added to the portrait. **Facing page**—A simple tapestry was attached to the existing backdrop using clamps in order to create an interesting, textural backdrop for this beautiful subject. To widen the area behind the subject, tulle was used on the left side of the image.

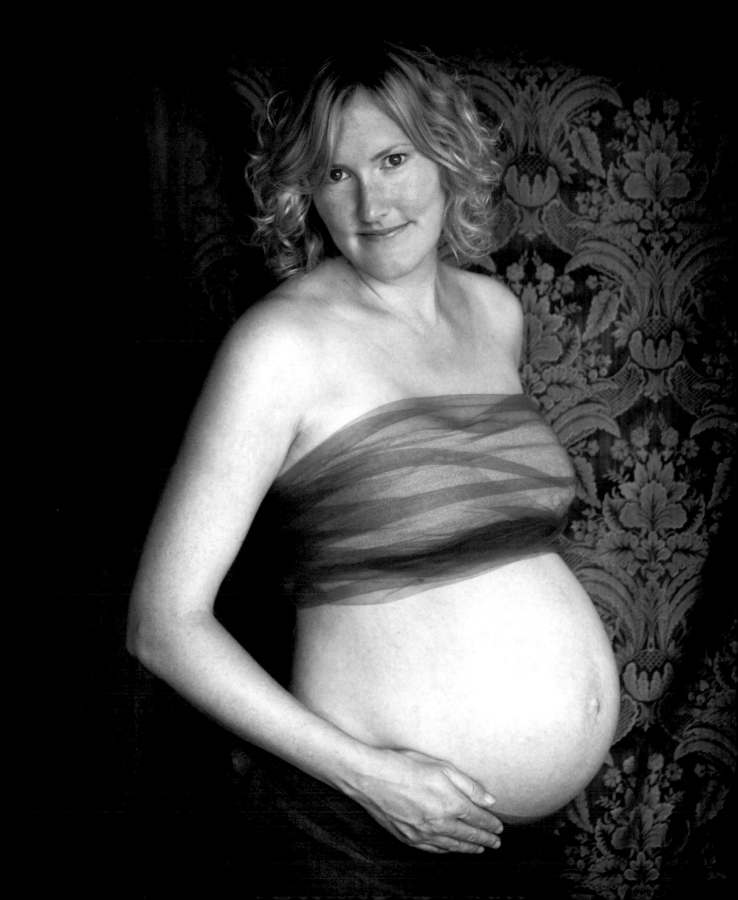

4. POSING

In photographic print competition, posing is one element that jumps out at the judges. An awkward pose will destroy any chance an image has of earning a high score.

Poor posing is also readily evident to the general public. When the subject's pose appears unnatural, the viewer will feel uncomfortable, even if they are not sure what it is that is technically wrong with the image. Conversely, when a photographer is able to capture a natural-looking pose, the viewer will be drawn into the portrait and will feel a connection to the subject.

Posing is an art in and of itself. Some people are born with the innate ability to position their subjects and immediately see comfort and grace in the pose. Then there are those of us who need to study, practice, and experiment in order to portray our clients in a way that looks natural and *un*posed. There are many steps to learning good posing techniques, and the sections that follow will outline a variety of techniques you can use to improve that aspect of your portraiture.

THE HISTORY OF POSING

From the beginning of time, people have created artistic representations of the human form. From cave drawings, to Renaissance painters, humans are fascinated with depicting one another. That fascination continues for photographers and their clients today.

In the early days of photography, excruciatingly long exposure times meant that portrait subjects had to hold a pose to ensure the success of the image. Today, advances in technology and a host of automated features allow us to easily capture an image in the blink of an eye! Posing, however, is one aspect of portraiture that still requires the photographer's attention and direction—and always will.

CONCEPTUALIZING THE POSE

Body language is a form of communication, and you want your image to communicate the right message! When we think of a pregnant woman, we have thoughts of motherhood, love, affection, protection, nurturing, warmth, and tenderness. Today, with mothers taking care of their bodies and our in-

▶ **CLIENT TESTIMONIAL**
"This was a unique and spiritual experience that provided me with a special bond with my unborn daughter."
—Ann-Marie H.

Facing page—Nestling the mother and father together created a feeling of security, love, and anticipation between the couple. Their tender interaction helped to tell their story.

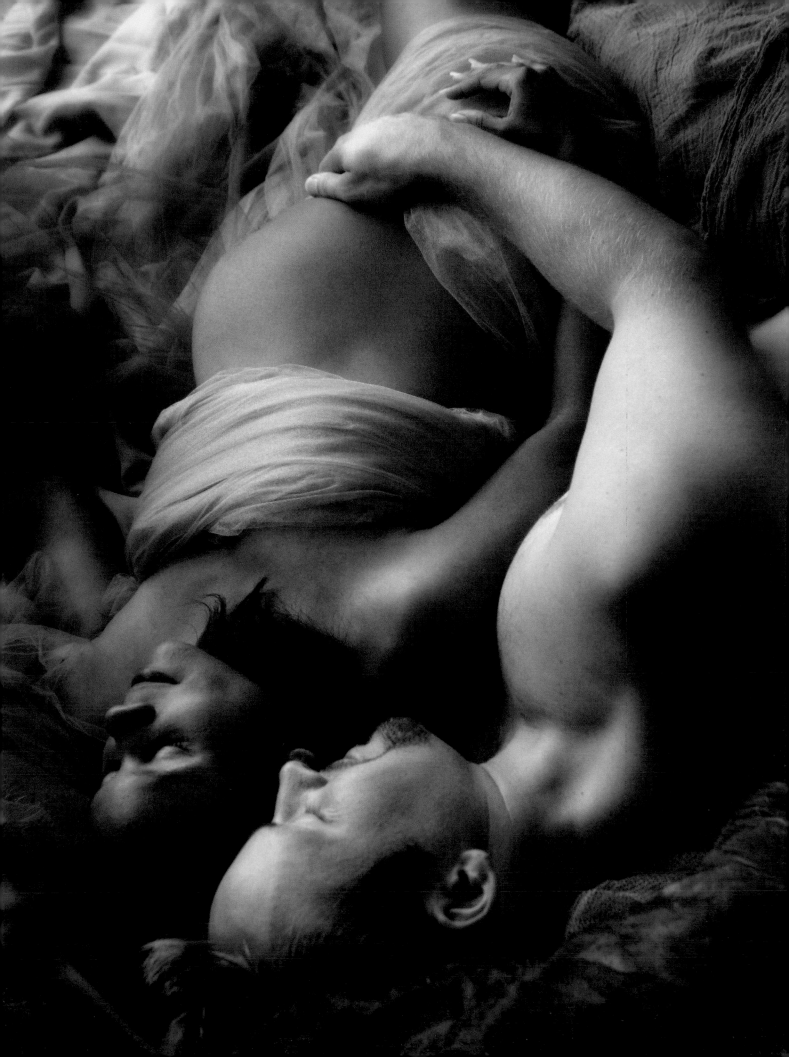

creasing societal appreciation of the beauty of the pregnant female form, we also see motherhood as a time of beauty. You might wish to convey any of these moods or feelings in your portrait. This time in a woman's life is fleeting and very different from any other stage, and it is a privilege to record it. Make it your goal to capture genuine emotion during the shoot.

THE BASIC POSE

A good pose is one that is flattering to the subject and provocative to the viewer. There are many poses—sitting, standing, or lying—that can easily meet this goal.

Standing. Photographers always seem to first tackle photographing a pregnant woman by having her stand upright. The assumption is that if she sits,

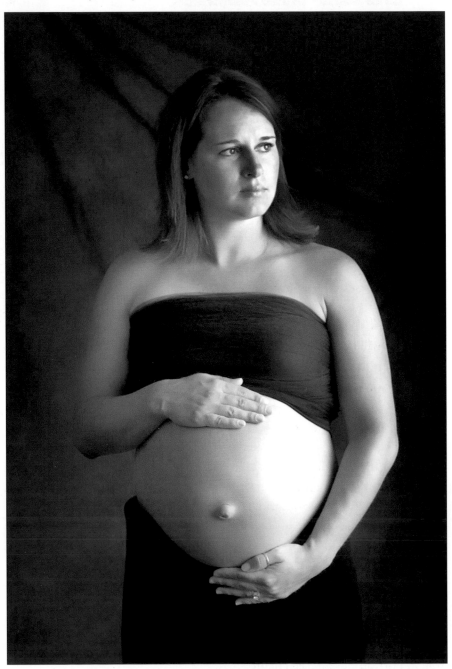

A good pose is one that flatters the subject and is provocative to the viewer. The details of the posing approach used to create this portrait are outlined on page 31.

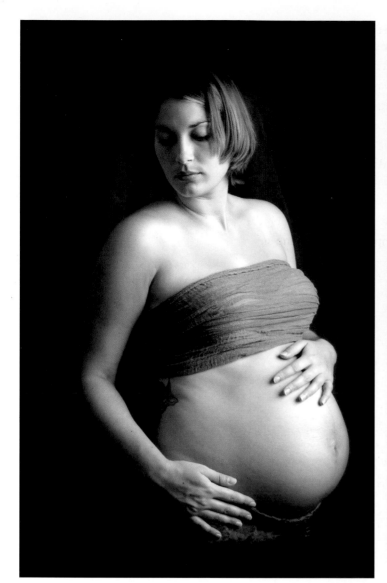

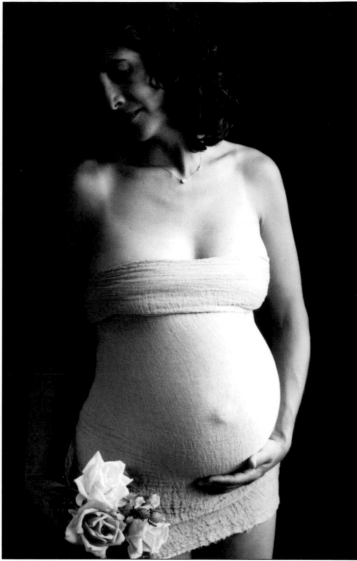

Left—You can easily create a nurturing mood in the image by having mom place her hand on tummy, holding and loving the expected baby. In this image, the mother held the flowers lower and to the side so that the view of her tummy is free of obstruction. **Right—**Many photographers prefer to begin the portrait session with a standing pose, and the technique illustrated here is a good option. The image was created using a single light and a reflector. The mom was asked to turn her body toward the main light and place her left had at the upper area of her tummy and her right had at the lower area. Her chin was angled toward her near shoulder. The intimate feel of this image is due in part to the fact that the subject's gaze is not directed at the viewer; creating a profile of the face or having the subject look at the camera would produce a different look.

the viewer will not fully see the developed midriff. While a standing pose can be a good place to start your session, you may find that the design and flow of the image is most difficult with a single standing subject than with multiple clients or a seated or lying pose.

An image of the mother alone will be more dynamic if you take the time to consider the best-possible placement of the hands, arms, and face.

In the image on the facing page, the mother's arms wrap around and hold her tummy, and she looks away with a thoughtful expression on her face. Note the serenity and poise that is conveyed by the subject's stance. The portrait shows the subject's strength and contentment. To create this mood, the subject's body was turned a few degrees away from the camera. She then turned her upper body toward the camera and turned her face toward the light. The position of her hands implies a sense of protection. By turning her body slightly away from the direction of her feet, a slimming effect was produced. Additionally, turning her face away from the direction of her body produced the desired S curve in the image. (For more on S curves and their role in portrait design, see chapter 5.)

Laying. The mother-to-be must be portrayed in the most relaxed, beautiful manner possible. When the mother is relaxed and surround by props like soft pillows and beautiful fabrics, you can capture something that transcends conventional pregnancy photos. In the past, many pregnancy portraits were taken with the mother-to-be in a standing position with the focus primarily on her midriff. However, that isn't necessarily the most comfortable or aesthetically pleasing position for the subject. One of the most beautiful ways to photograph the mother is with her lying down in such a position that the woman becomes more relaxed and serene. From a technical viewpoint, her body is more elongated and appears thinner.

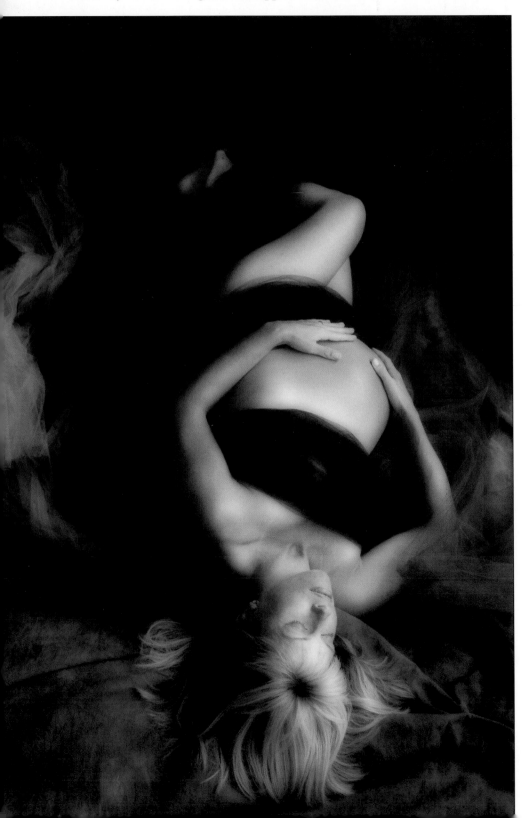

Photographing a client in a lying pose elongates her body and makes her more comfortable. It's a win–win situation.

When posing the subjects, directing the gaze of your subjects can help tell the story. Here the mother and the older sibling are looking off together, as if they are looking to the future as a loving and supportive family.

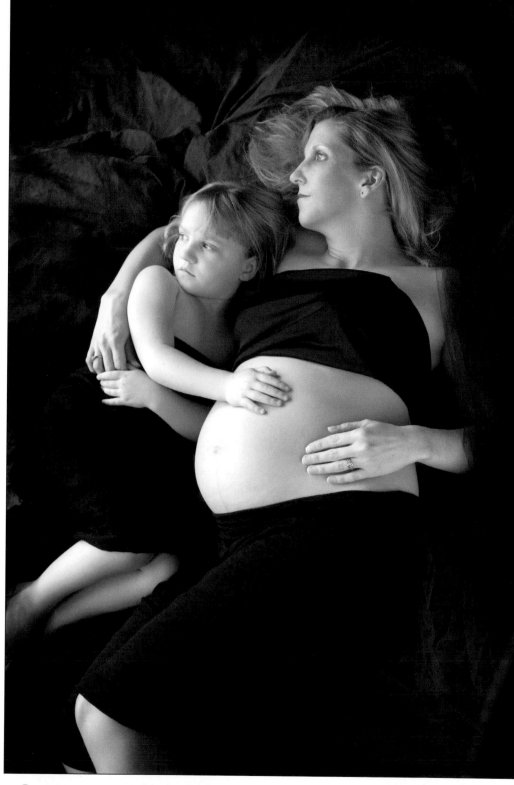

Create your scene with beautiful fabrics in colors that complement the subject. Then have her lie down in the middle of a bed or on the floor (note that it will be easier for your late-pregnancy clients to get up from the bed than from the floor). Place her legs in a slight bend, with her arms relaxed and her hands focused on her pregnancy.

Good posing of the hands is critical, as the hands express emotion. How and where you pose the hands can make an immense difference in the overall quality of the pose and the message you are trying to convey in the image.

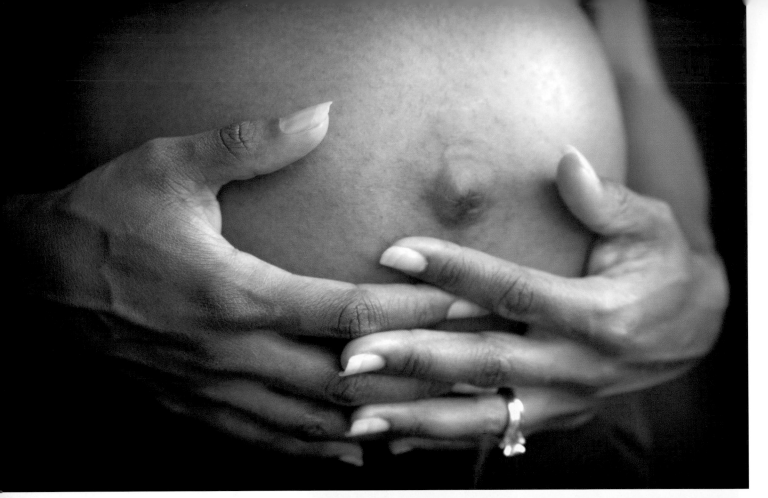

The hands can speak volumes about the love the mother has for the baby, and hands touching between a couple tell about their shared love and anticipation. Additionally, the position of the hands, or the leading lines formed when a couple joins hands, can create the needed compositional elements that add polish, guide the viewer's gaze through the image, and create a dynamic feel in the image.

Making the posing of the hands look natural can be difficult for some subjects and photographers. One easy method is to have the hands gently holding on to something. The mother can gently grasp the edge of the fabric she is draped in, or hold a bouquet of

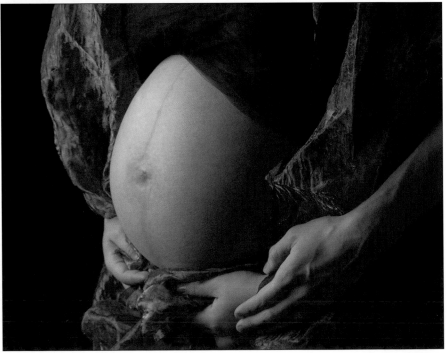

flowers, or simply rest them on her tummy. Make sure her hands are not positioned in the center of her tummy area but are placed side to side or top to bottom. If the mom's hands look unnatural, ask her to take her hands off of her tummy or let go of the object she is holding for a few seconds, then place the hands back. Many times this will result in a more natural look. There will

Having the hands posed around the baby-to-be conveys a sense of protection and nurturing. In an image of the hands and tummy, an interesting contrast is formed between the mature adult hands and the anticipation of new life.

be times, however, when you will have to demonstrate with your own hands the position you want with the fingers in and the placement you are seeking.

Keep in mind that a flattering hand pose is one in which the fingers are spread slightly apart and bent away from the camera. Avoid having the back of the hand squarely pointed at the camera. Also note that the palm should never be faced toward the camera. If a hand is held away from the body, have the middle finger bent slightly more than the other fingers. This position is used by ballet dancers when the hand is held away from the body, and it produces a graceful look.

You can capture the image with the camera positioned by the feet or the head; either perspective can result in a breathtaking presentation.

Seated. By having your seated subject posed with her back straightened, you can present a full view of the mature pregnancy. In the image below, the mother is beautifully portrayed as she sits with her legs bent and to the side.

A standing pose is not your only option for posing your pregnant subject. As shown here, a seated pose can be elegant—and it may actually provide your client some relief from an aching back or knees.

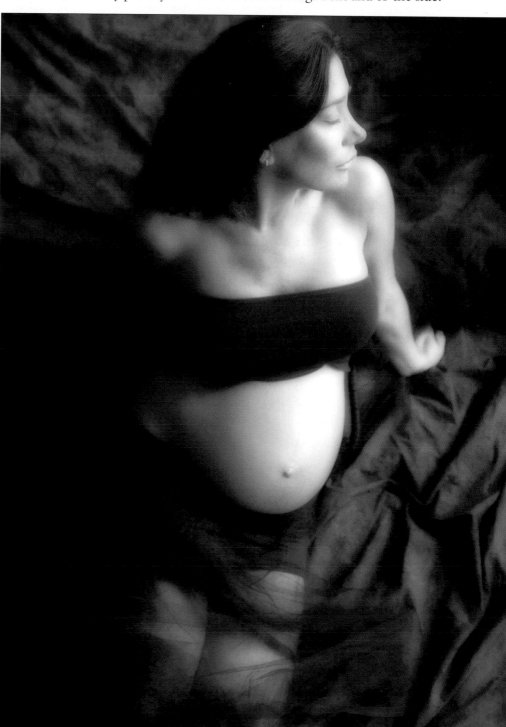

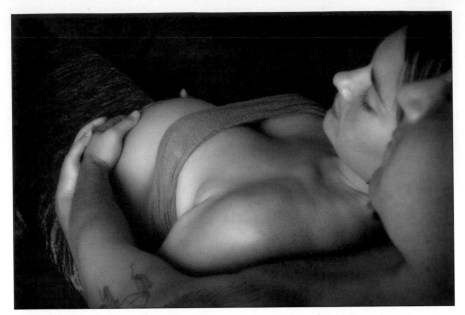

Left—This image of a couple has a unusual feel as the point of view is from above traveling down the embracing couple. **Facing page**—Here the unusual angle, from the top of the mother down, creates an interesting and artistic perspective in the image.

The carefully designed lighting setup cast more illumination on the mother's left side, leaving part of her form in shadow. This allows for a slim, smooth presentation of the body. Turning the subject's head to the side brought her striking profile into view. With her eyes closed, a sense of calm and serenity was achieved.

PERSPECTIVE

To create the dramatic perspective, try photographing the subject from several angles. The simplest change is to shoot from a lower camera angle. Once you have the mother in a lying position, drop the camera down to right above her head level. Take care to arrange her body in a flattering pose, with knees slightly bent, hands on the body, and head at a tilt. Looking through the viewfinder, make sure lines of the body lead the viewer's gaze from the left side of the image, to and across the graceful lines of the subject's body, and to the other side of the frame.

You can also consider creating an image from above the subject. When the mother or couple is sitting down, stand directly above her or use a ladder to get a fresh perspective. This viewpoint can slim the subject and make her midriff the focal point of the shot. Adding dramatic lighting from a single source so that the light cascades down the side of the subject can create a calm, quiet mood in the image.

You can also capture an image that shows the mother's perspective. By standing behind her and photographing over her shoulder, you can capture her hands—or the couple's hands if you're photographing the mom and dad—around the tummy.

CORRECTIVE TECHNIQUES

Every once in a while you will need to photograph a mother who has gained more weight than she would have liked. To flatter the subject's face, select a pose and camera perspective that allows her to lift her head and push her chin

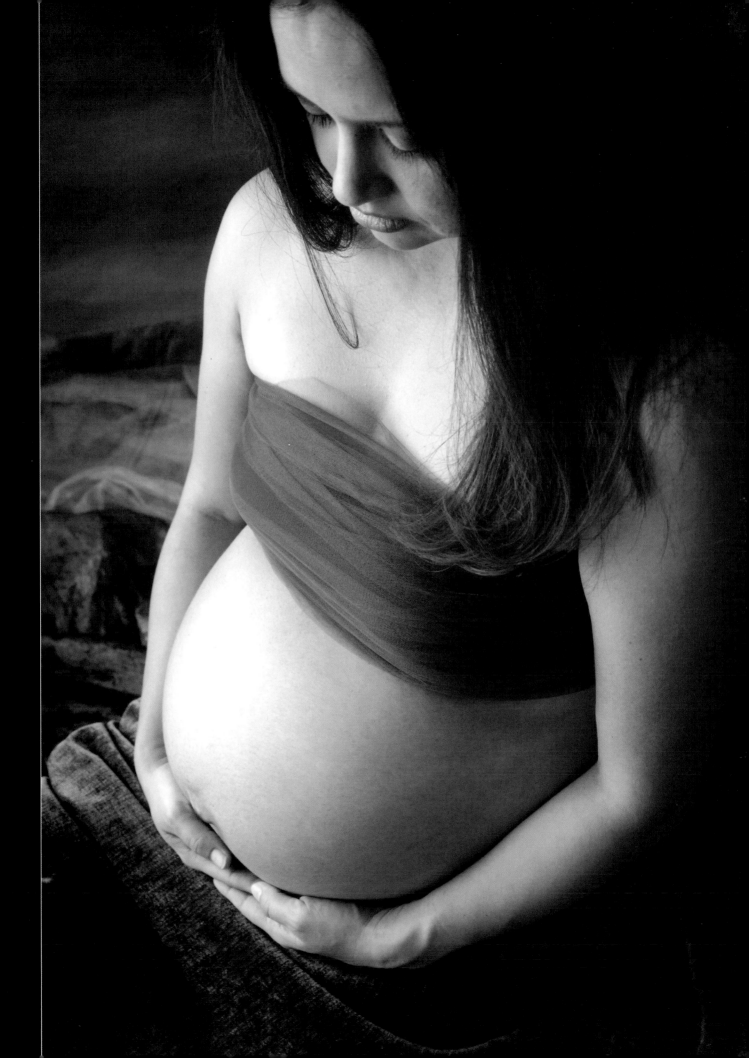

very slightly forward. Capturing the image from above will also help to downplay the double chin and give her a regal look.

As many pregnant women put on weight, they become increasingly self-conscious about the size of their upper arms and thighs. To ensure a slimmer presentation, have your subject position her upper arms slightly away from her body, not pressing against her side. Providing a little space between the knees will visually slim the thighs.

Consider using fabrics to hide or reduce the apparent width of the arm or legs. Remember that while tulle is perfect for hiding imperfections, it should not be used to completely cover the subject's skin.

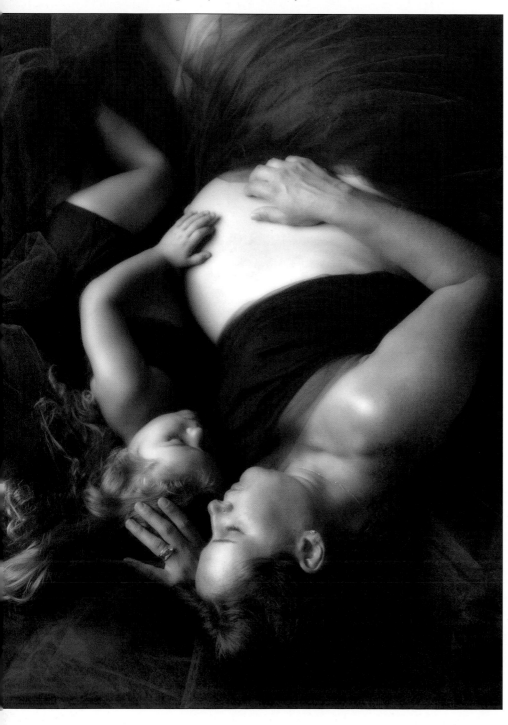

Left—The lines of the mother's and daughter's bodies form undulating lines that draw your eye across the image frame. **Facing page**—For a very dramatic image, move to a nontraditional position. Here, capturing the image from above, plus having the mother's face follow the line of her body, created an unexpected image.

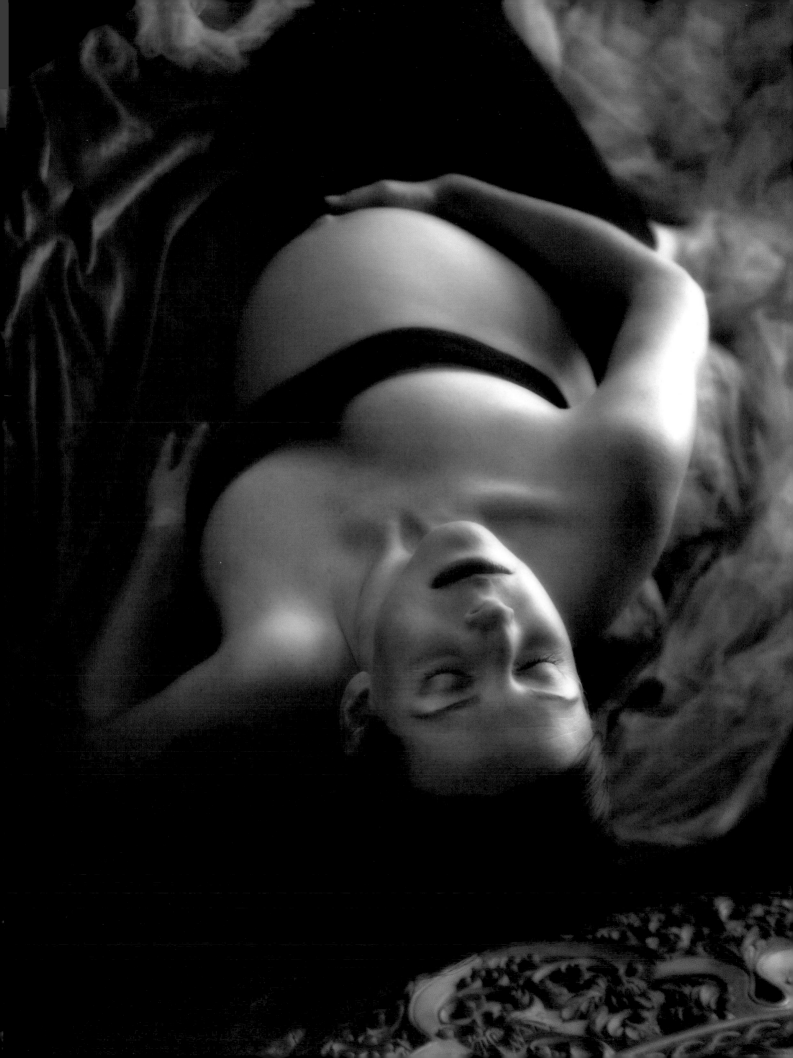

Lighting your overweight subject from one side will visually slim the body and face, as the eye will be drawn to the well-illuminated areas of her form and will not linger on the shadow areas.

POSING COUPLES

Photographing the mother and dad together is one of the most rewarding aspects of creating maternity portraits. The couple's joy, love, and anticipation is intoxicating—especially with the first child. The portrait session allows you to capture an artistic representation of their love and union.

There are actually several ways to effectively pose the couple. You might start by having the mother standing, and simply have the father wrap his arms around her from behind. The camera angle can be from the front or side. This pose will work best if the father is taller than the mother. For a traditional look, have the father stand beside the mother, with one arm around her back and the other hand placed on her belly and meeting her hand.

You can also take the opportunity to create artfully styled images of the couple lying down. There are many advantages to selecting a lying pose. This

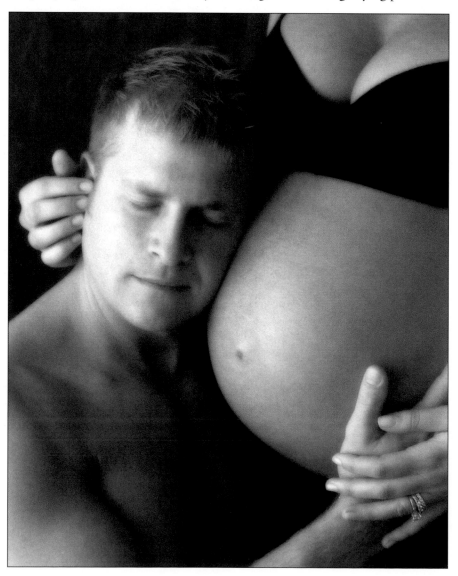

An image of the father and the tummy beautifully illustrates the emotional connection the father has with the baby.

Top—Note the way that placing father's hands on the mother's tummy creates a connection between the couple and emphasizes his connection with his child, as well. **Bottom**—In this sweet image of the father kissing the mother's tummy, the story is about the baby and dad, and the mother becomes the "prop" or accessory to the image. This image was simple to light, with a large sliding glass door in the couple's dining room area. Notice the position of the couple's hands, touching in a loving way. The physical connection is important to the overall feeling of the image.

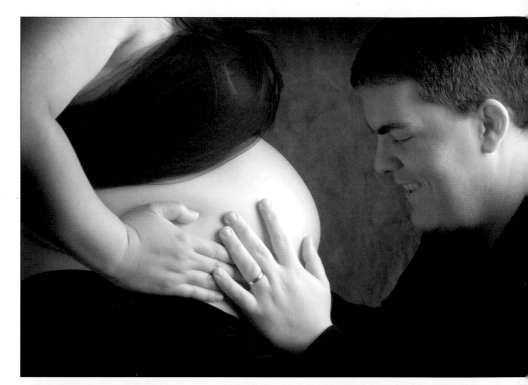

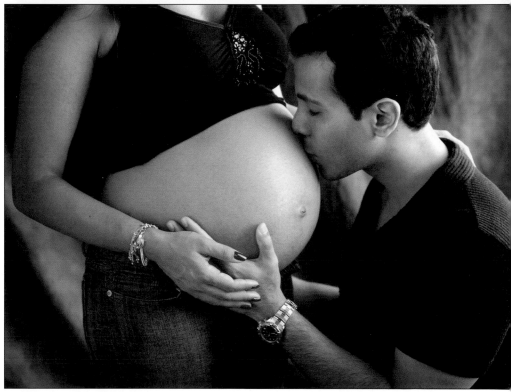

position is more comfortable for the mother, of course, but it can be relaxing to the father as well. Many fathers are not initially agreeable to being photographed. Once you get the couple to lie down together, the father usually relaxes a great deal and takes direction well. In this pose, it is easy for the father to wrap himself around the mother. In this position, the dad illustrates his role of protector and supporter of the mother and child. He can place his hands on her tummy, and if he's feeling a little camera shy, he can nestle his

head next to the mother's with his eyes closed. A heavier subject can lift his chin to reduce the "double chin" look.

If you are photographing a man and woman who are not comfortable with the idea of lying down, you can use a seated pose to depict the feeling of shared intimacy. Start with the mother seated, with her knees turned at an angle to the camera. Next, have the father sit behind and slightly to the side of the mother, with his knees apart so that she can nestle into him. Be sure that the mom is not blocking the father's face. Have dad wrap his arms around the mother and gently place his hands on her belly, arms, or hands. While the seating pose can work in a pinch, it allows for less variety than does a lying pose.

▶ START WITH THE OUTFITS
Warm up the mother and especially the father by first creating simple portraits of the clients wearing clothes they selected for the session. As they become more comfortable, move slowly into more creative shots using fabrics and props.

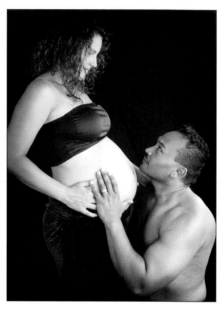

Left—An embracing couple is a wonderful way to tell the story of the anticipation the parents have for the arriving baby. Here the father is taking on the role of protector with his arms around the mother and hands on her tummy. **Right**—A connection between the couple speaks volumes to the viewer. The couple here are simply making eye contact, but this simple look tells us so much about their relationship and love.

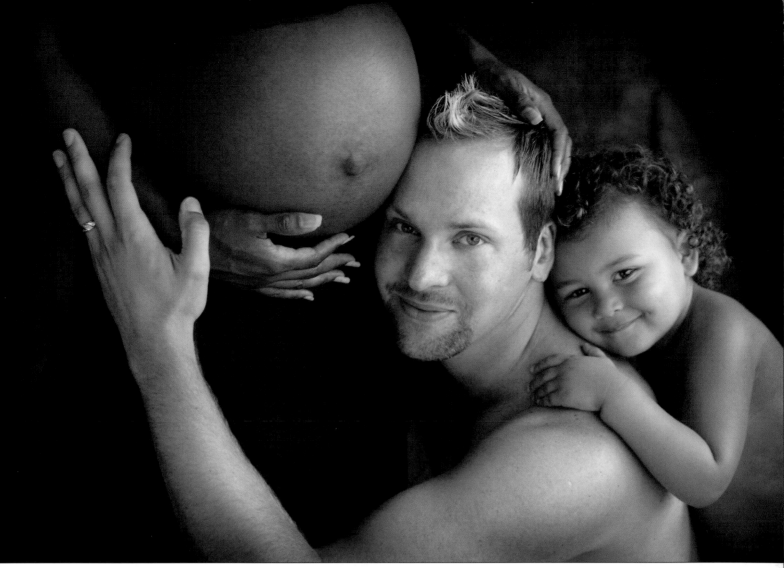

In this image, the mother's hand is gently placed on her husband's head, and his hand reaches up to rest on her forearm. With the couple's son leaning on the father, the whole image conveys a warm feeling of family togetherness. If you look closely at the image you will also notice a series of triangle patterns through the arms and heads. The repeating patterns give the image a feeling of harmony.

Another favorite pose for couples is an image of the baby-to-be with the father. This pose allows you to showcase the relationship between the father and baby in a way that including a fuller view of the mother does not accomplish. Adding an older sibling or siblings to the daddy-and-tummy pose can also document the family dynamics and show the family members' sense of joy and anticipation.

While the subject is the pregnancy, evidence of the mother is very important even with the father or siblings in the picture. By having her hands touching her belly or the other subject, you will create a loving and affectionate mood.

Including the children will often make for a cheerful, fun image. However, including kids in any portrait session presents some unique challenges. We'll review some strategies for working with children later in this chapter.

Coaxing Dad. Some fathers are resistant to the idea of participating in the session. This is another benefit to conducting the session in the subject's home, as the father won't have to be coaxed into going to the studio. Despite their hesitation, fathers surprisingly turn out to be one of the biggest enthusiasts once you get them involved. Start with asking the father to be your "helper," getting him actively involved in the photographic process before

you put him in front of the camera. Fathers can help with everything from getting a pillow to moving furniture to holding reflectors. When the father feels like he is assisting he has a tendency to relax and takes a personal interest in the outcome of the images.

POSING WITH THE CHILDREN

Working with children is always a challenge. With the dynamics of the family changing when a new baby comes, the photographer needs to be sensitive

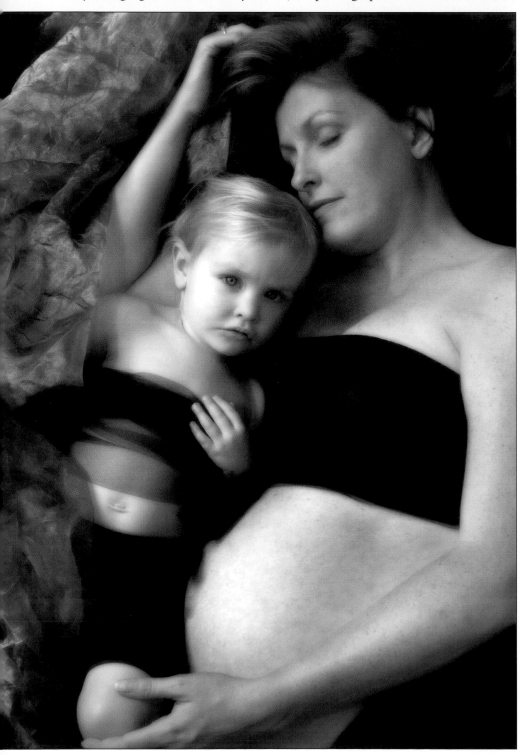

There are those moments that make it all worthwhile, when everything comes together and the magic happens. Here, in a split second, the child and mother forgot where they were and expressed their love and affection for each other. Only in a relaxed and "safe" place can the client and subject let go and become completely natural. When this happens, the photographer only has to capture that moment.

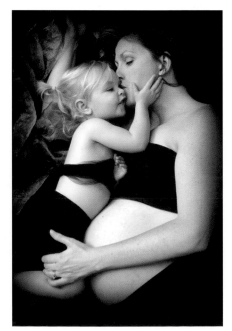

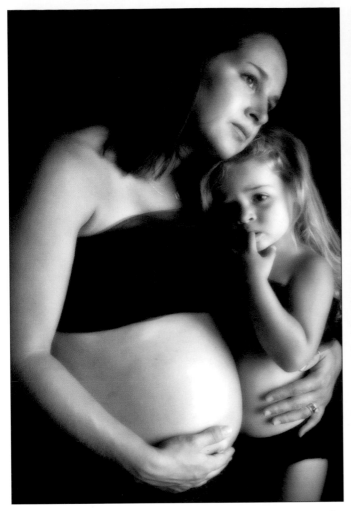

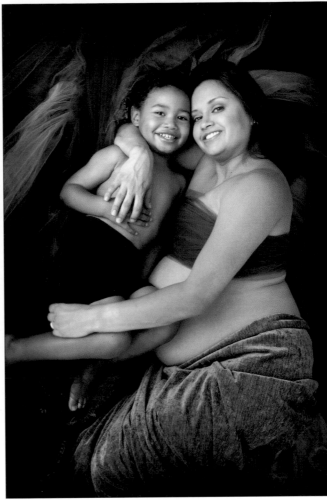

Your best defense when photographing young subjects with their pregnant mom is to position them close to mom, establish the mother–child connection, and make them feel that they are a critical element in the portrait.

to any anxiety the children may be feeling. Having them participate in the maternity session can be a wonderful way to celebrate this impending change while showing the older children how important they are to the family. Being playful with the children will go a long way toward helping you ensure an enjoyable session.

Toddlers and Preschoolers. Often the session will include a young child (or multiple young siblings). The greatest challenge will be the toddler to preschooler. Letting them feel like they are the most important part of the portrait session will go a long way toward getting them to cooperate. For the younger child, keeping them close to the mother and either embracing her or being embraced by her may be the only means to capture the mother and child in the same frame.

Five- to Seven-Year-Olds. Take care with little boys, and sometimes girls, around five to seven years old. At this stage they may make silly faces when you ask them to smile. One way to get around this is to ask them to smile without showing their teeth or to give you a soft or little smile. Having the little one lean against his mom's tummy can also help to make for a calmer, more peaceful subject and great expressions.

Older Children. When older children are to be included in a family portrait, it is best to handle them as adults. Pose them with the mother similar

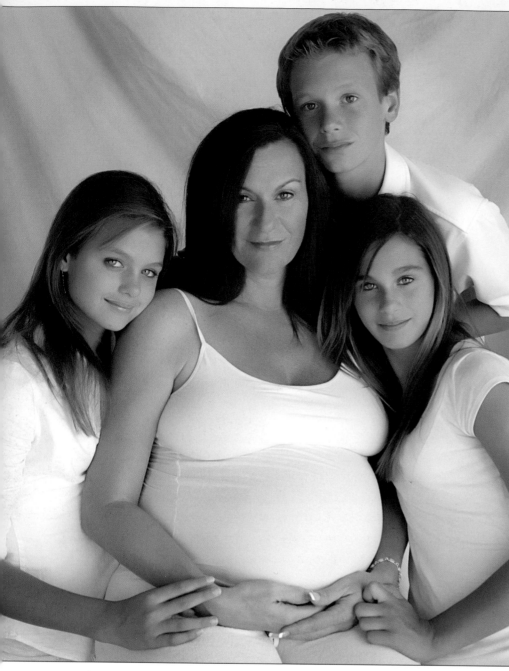

This family group includes thirteen-year-old triplets—and capturing them with their mother was a challenge. Here the solution was to place all of the subjects as close as possible with the mother sitting down.

to how you would pose a spouse. The difficulty lies with having the faces and the center of attention—the expectant mother—all together in one frame.

POSING GROUPS

One way to really tell a story is to capture the emotion and relationship in a family. With all the complex dynamics that go on in families, an effective photographer is one who can put the subjects at ease and capture the interplay of the different personalities. Taking the above-mentioned steps toward creating a relaxing, calm attitude and environment will go a long way toward helping you capture those precious moments.

Also, by giving individual attention to each subject before and during the session, you will establish a relationship with every family member. Take a

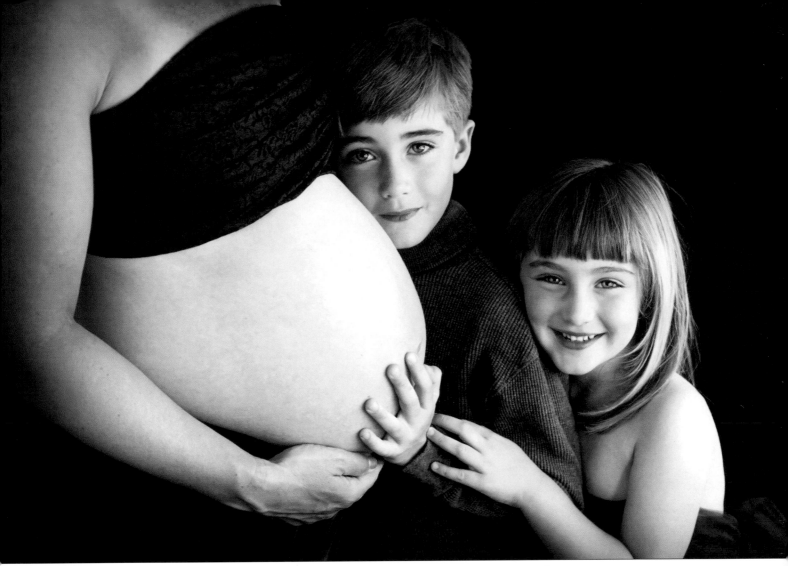

Lots of coaching, talking, and encouragement helped these children relax and elicited joyful, sweet expressions. Sometimes, having a small child anchor his or her head against mom can help calm the young subject and ensure a calm, beautiful expression. Such was the case with the boy in this portrait.

few minutes prior to beginning the session to explain what your ideas are and how each individual is critical to the finished artwork. This will produce an attitude of cooperation.

To produce intimate relational images of families, the individuals will have to be positioned closer together than is customary. Explain to your subjects—and show them with your hands—how close they will be, emphasizing how the finished image will look. It's helpful at this point to joke a little with them to break the ice and help them relax.

GAINING EXPERTISE

Learn from the Masters. One of the best avenues to gaining an understanding of posing and developing a cache of excellent posing ideas is to study well-known paintings and photographs. Paintings by Leonardo da Vinci, Michelangelo, and other prominent artists depict the human form with grace. By seeking to replicate a simple tilt of the head or the extension of the hand as seen in a painting, you can learn how to create a pose that will appear natural and flattering. Though posing may not come naturally to you from the outset, as you work with your subjects and experiment, and practice your skills, you'll find that posing your clients will become almost intuitive.

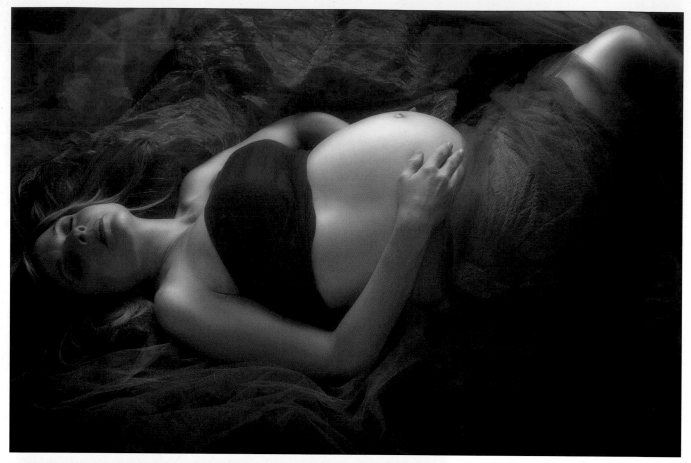

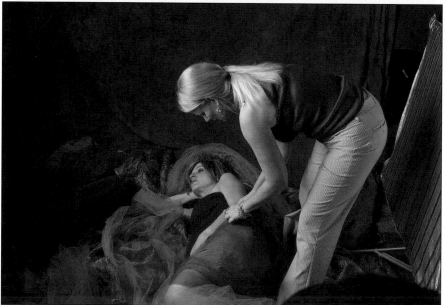

Top and bottom—One of the best ways to learn good posing positions is to watch other photographers work with clients and models. **Facing page**—Here the family was so relaxed and comfortable during the session that they were more than willing to touch closely.

A second way to develop good posing technique is to study the work of other photographers. Experienced portrait photographers establish a repertoire of poses that will help them to accomplish a desired look. While observing another photographer working, take notes on the subject's stance and posture for future reference.

Observe Dancers. Dancers are masters of using their bodies for self-expression, and their grace in doing so is unmatched. Photographer Lois

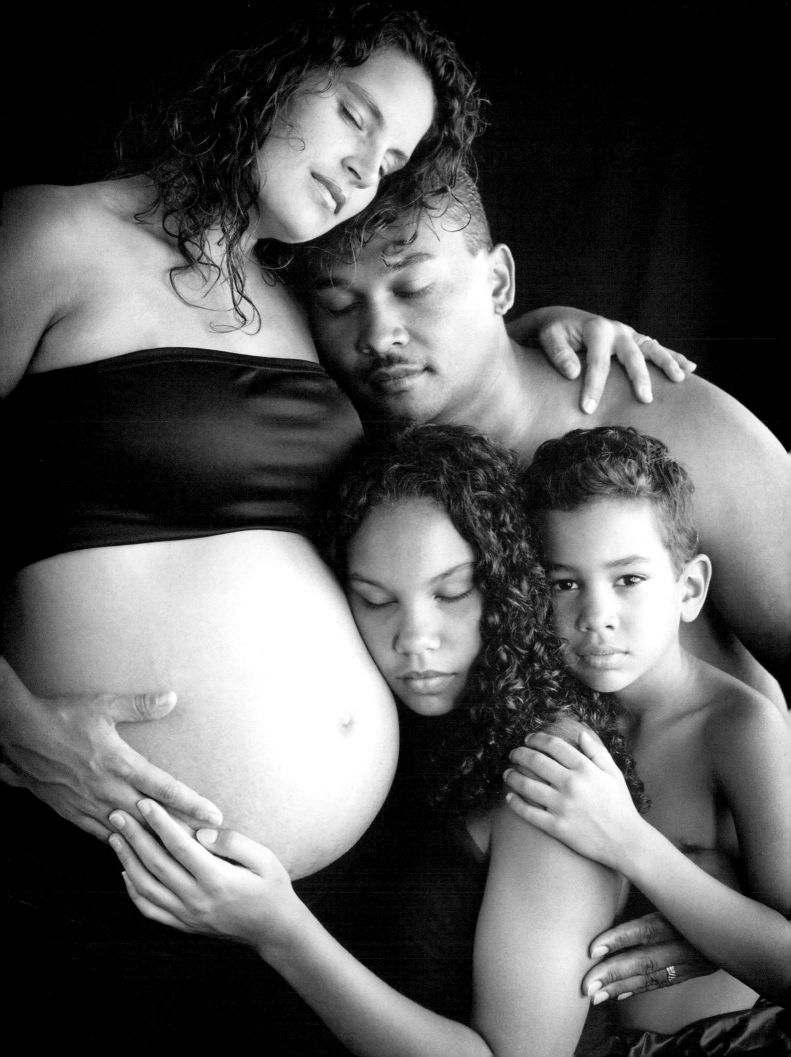

Greenfield is known for her strikingly beautiful images of dancers in motion. If you examine her work, you will find hundreds of examples of hand posing, facial expressions, and body movements that will inspire your posing work.

Create a File. Many photographers make it a habit to browse through magazines and catalogs in order to create a file of their favorite poses. The file can serve as a handy reference when working with a model or subject. By using your office copier to reduce the size of the images to fit on 3x5 cards, you can easily store them in your camera bag, pocket, or purse and review them when you need inspiration.

Posing Books. An obvious option for cultivating a better understanding of the subject of posing is to consult one of the many books devoted to the topic. Bill Hurter's *Portrait Photographer's Guide to Posing* (Amherst Media, 2004) is an excellent resource that features poses that many of the industry's pros favor, from classic to cutting edge. Hurter details everything from basic posing, to posing groups, and corrective posing techniques. *Professional Posing Techniques for Wedding and Portrait Photographers* (Norman Phillips; Amherst Media, 2006) and *Posing Techniques for Digital Photographers* (Jeff Smith; Amherst Media, 2005) are equally good resources.

Design Principles. Developing a feel for the shapes and visual patterns that are considered aesthetically pleasing can also help you to make the most of every pose and overall image composition. These principles will be discussed in the following chapter.

Once you have a series of successful poses, you can improvise and easily add images that feature great expressions you elicit from your subjects. In similar poses shown in this book, the male subject is shown with a serene, contemplative expression. This portrait was made to capture the whimsical expression and sense of anticipation that shows on the father's face.

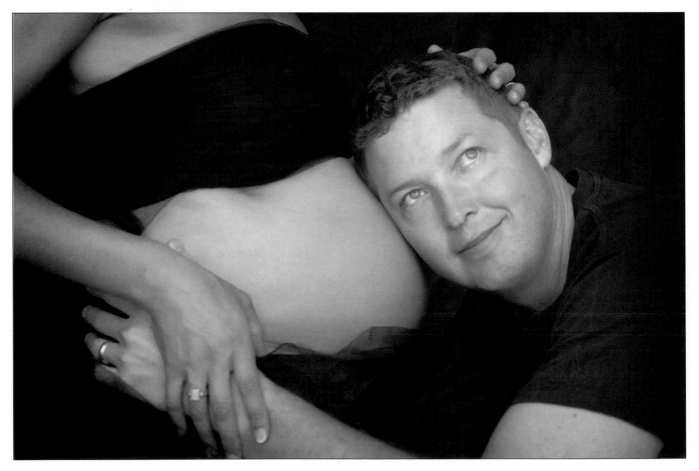

5. COMPOSING THE PORTRAIT

The importance of composition in creating maternity portraits should never be underestimated. Think of composition as a road map that viewers will use to reach their destination—an appreciation of the beauty of your subject. Some of the important features of this map include the subject's relationship to another subject, to the light, and the angle of view. Also included are the relationship between the hands, face, body, and legs of the subject—as well as any props used in the image.

Design is similar to posing; it has to be practiced. Take the time to read books on the topic, take a foundational class on design, study well-known paintings, and analyze portraits created by photographers you admire. In the beginning, take practice images with willing models. When you are working with subjects, strive to perfect the composition—don't allow the image to just happen. By working on your compositions, you will also enhance your creativity.

BALANCE

Balance is the visual aspect of an image that creates a feeling of harmony—a sense of equilibrium and an even distribution of weight—in the composition.

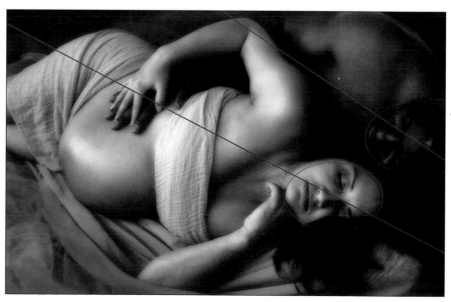

In order to create balance in this image, the couple was placed side by side. With the mother being much smaller than the father, she was placed both closer to the camera and in front of him. The effect was further enhanced by ensuring their heads were aligned and bodies were posed in a similar direction.

A composition can feature objects that are evenly spaced or of the same size and weight. Alternatively, you can add to the composition a secondary subject that is similar to the main subject in color or size.

It may seem as if achieving visual balance in an image with two subjects with a height difference of more than a foot would prove difficult. However, by lying the couple down, the difference in height was quickly and easily diminished, and balance was achieved.

RELATIVE SIZE

In a portrait of two subjects, the person who occupies the bigger portion of the frame will draw the viewer's gaze. The father in the image on page 51 is physically larger. Because we wanted the belly to be the focus of the image, we placed the mom in front of the father. In this position, she obscures much of his large frame and gains visual prominence. The height discrepancy also allows us to have him wrapped around the mom to suggest a sense of unity and protection. This helps to build the storytelling quality of the image.

Though you might deduce that the largest subject in the frame will *always* draw the viewer's attention first, there is an exception to the rule: in a family portrait of a standing woman, man, and child, the smallest subject will draw the viewer's eye first. You can capitalize on this phenomenon by composing a standing image of the family so that the height discrepancy is highlighted. This can be useful when you want to document the way the small subject is feeling about the pregnancy and impending birth. If you want a portrait in which the subjects are more or less equally prominent, you can seat the mother and father and have the child stand close so that the three subjects' heads are more closely clustered together.

RHYTHM

Rhythm is created by using repeating elements in an image. Though the portrait above features only two subjects, the lines of their bodies create rhythm.

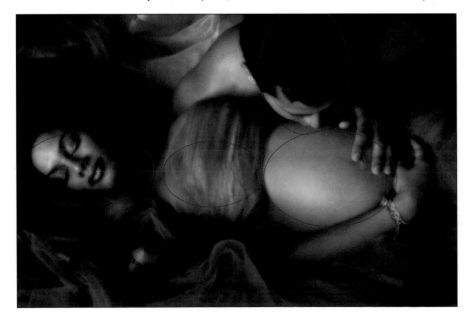

Note how the repetition of oval-shaped elements—the woman's head, chest, and tummy, and the man's head—create rhythm in the image.

The eye is curious about and drawn to subjects that are not centered in the frame. An off-center subject also leads the viewer's gaze across the frame. In this image, the face of the mother, the main element, is placed in a one-third area of the image, the hands are placed in another, and the midriff fills another.

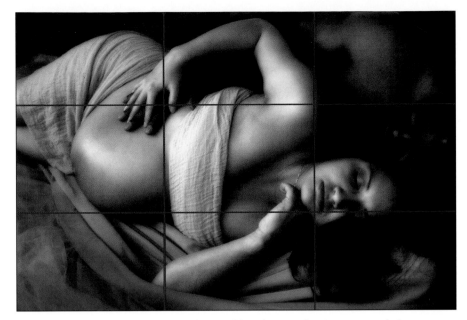

Notice the repeating triangles formed by the mother's arms and the repeating circular forms of the heads and belly. These rhythmic elements give the image a sense of movement.

RULE OF THIRDS

The rule of thirds is a compositional tool long used by photographers to determine the most effective subject placement. In essence, the rule states that subjects are more visually compelling to viewers when placed one third from any one of the outer edges (horizontally, vertically, or both) of the frame. To ensure a more effective composition, visualize a line placed one-third from the top of the frame and another line placed one-third from the bottom of the frame. Next, visualize a line positioned one-third from the left edge of the frame and another positioned one-third from the right edge. When you're finished, you should be able to conceptualize a tic-tac-toe grid over the image frame. Note that there will be four points at which the vertical and horizontal lines intersect; these are called power points and are thought to be excellent places to position main areas of interest (e.g., the eyes and the tummy).

LEADING LINES

Horizontal, Vertical, and Diagonal Lines. Vertical and horizontal lines convey a feeling of motion in an image, especially when the lines form repeating patterns. Vertical lines represent stature and strength. Horizontal lines represent calmness and stability. Diagonal lines can also be used in the photographic frame to lead the viewer's gaze to the subject. Those of us who live in the Western world read from left to right. Therefore, as we take in an image, we tend to start at the left edge of the frame and follow real or implied lines in the composition to view the main subject of the image.

As you compose your image, strive to create lines that lead the eye from the left edge of the frame, through the image, and to the subject. For instance, posing your subject so that she is lying diagonally across the frame,

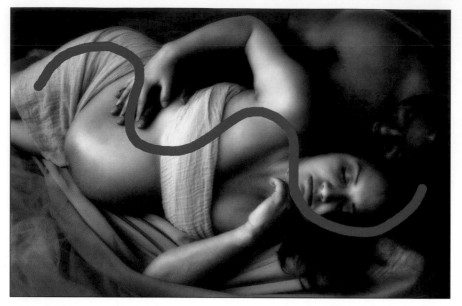

with her legs to camera left, can compel the viewer to follow the line of her legs toward her midsection, which should, of course, be prominent in the pregnancy portrait. Angling her arm and resting her hand softly at her chin can create another line for the viewer to follow; this one, of course, would draw the viewer's gaze to the subject's face—another focal point of the image.

Note, too, that the overall position of the subject's body, and how it relates to the frame, also impacts the visual flow of the image. For example, a subject photographed lying diagonally across the frame will appear more dynamic than one photographed sitting upright.

S Curves and C Curves. Curved lines are also visually compelling. They are a natural choice for drawing the viewer's gaze through the image. A curved line or curved subjects represent gracefulness and tranquility. Two commonly used lines are the S curve and C curve.

The S curve is an ideal design element for composing a portrait of a pregnant woman. In the left-hand image (above), there is a repeating (or double) S curve that guides the eye from the upper-left edge of the image to the lower-right area of the frame, leading the eye to rest on the subjects' relaxed, content expressions. Their pose also produces a sense of rhythm and repetition. The image is full of grace and femininity, and the rolling lines add a sense of movement to the portrait that keeps the viewer's eye engaged.

A C-shaped curve is another natural choice when composing a pregnancy portrait. In the right-hand image (above), the sweeping curve of the mother's body produces a gentle C shape. There are also C-shaped lines through the woman's arms, and her hands are placed gently upon her tummy in a suggestion of protection, drawing our gaze to her rounded midriff.

COLOR HARMONY

Color has the power to evoke emotion and enhance the mood of an image. The color blue, for instance, is often used to portray things as cool and remote (just think of the saying, "he was feeling blue today"). Cool colors re-

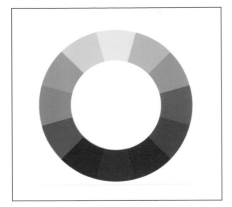

The color wheel.

cede in the frame. Warm colors tend to have the opposite effect on viewers; they are often used to depict emotional warmth and comfort, hominess, or passion. Warm colors visually advance in the frame.

When looking at the color wheel, we see that greens, blues, and purples are on one side; these are the cool colors. Yellows, oranges, and reds are on the opposite side of the wheel; these are the warm colors.

To achieve the most beautiful image possible, you will want to coordinate the colors in the background and clothing, ensuring that they complement the woman and help to create the desired mood in the image. Selecting colors that complement the skin tones will create a feeling of warmth and harmony. A majority of people, regardless of their skin tone, look healthy and radiant when surrounded by earth tones. Warm tones like gold, brown, mocha, and sienna enhance the glow of the subject's skin. Try using gold tulle with a mocha-colored gauze and note the impact on your subject's skin.

SUBJECT'S RELATIONSHIP TO THE LIGHT

The subject's position in relation to the light source is a factor in creating the overall mood of the image. Light coming from the camera angle directly toward the subject will create an open mood. Light from the side can be seen as thoughtful, and light from behind is dramatic. Just as you use balance, size, rhythm, and other design elements to tell the story in the image, you can use light to compose your image. In the following three images (below and on the following page), the direction of the light is critical to the mood established in the portraits.

Left—In this image, the main light was placed near the camera and directed toward the subjects. Along with the white clothing and background, the lighting helps to create an open, welcoming mood for the image. **Right**—Moving the lighting to the side of the subjects produced a more thoughtful mood.

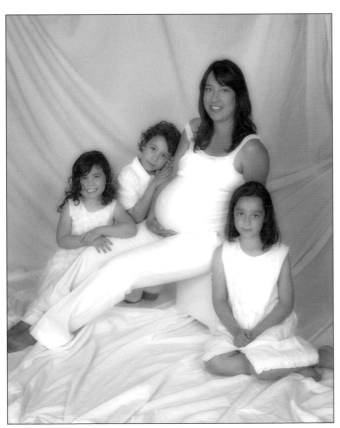

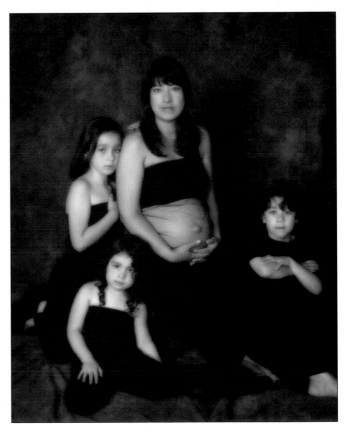

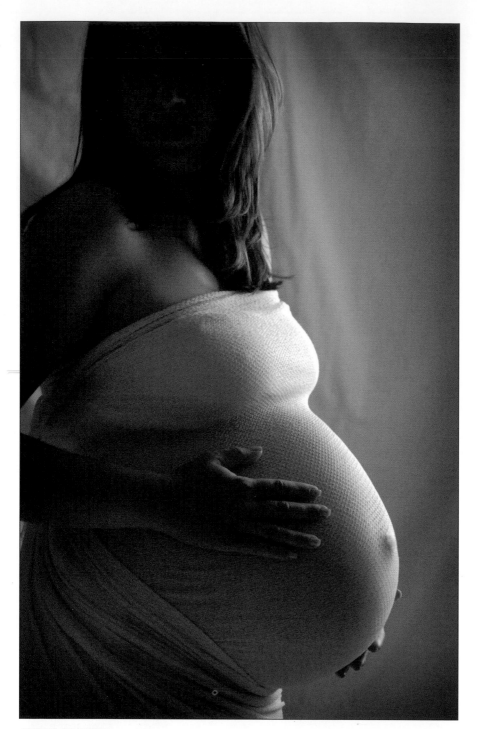

Note the dramatic feel of this portrait. To produce the effect, the light was placed behind the subject. The highlights and shadows keep our attention focused on the tummy.

ANGLE OF VIEW

Finding a fresh and different perspective can transform a simple portrait into a work of art. Once you place your subject in the composition, move around your subject looking for a unique perspective to capture the image. Keeping the basic design principles in mind, and seek out a view you would not normally capture. Moving above the subject, look down and follow the lines of the neck, arms, and hands to the main focus of the image, the mother's midsection. Alternatively, you can drop down to a lower camera angle and use the leading lines formed by the mother's body to pull the viewer from the bottom-left corner to the top-right area of the image. It is this creative ap-

proach that will take your images beyond typical portraits and into more of a fine-art realm.

TROUBLESHOOTING

When you are working with a client, take the time to step back, look over the scene, and see if it appears balanced. It will be readily apparent when there is a flaw in the design. Ensure that your fabric and background choices are in harmony and make the subject's skin appear to glow.

Move the subject or move around the subject to create rhythm and repeating shapes in the composition. Place key components of the image in the one-third areas of the frame. Determine where you can create an S curve or C curve by moving the subject's legs or arms or turning the torso the opposite direction from the face. Ensure that these lines and shapes pull the viewer's gaze into and through the frame.

Remember, the use of design elements is imperative to the success of the image. With practice, incorporating the compositional guidelines outlined above will become second nature.

The placement and positioning in the elements in this portrait draw the eye to the connection the father has to the mom and baby.

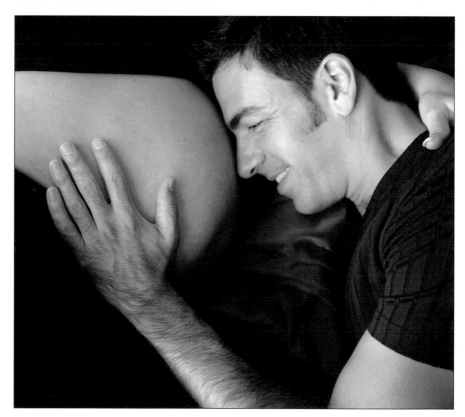

6. LIGHTING IN THE HOME

Welive in a three-dimensional world, where the objects we encounter have width, length, and depth. Paintings, drawings, and photographic images, however, are two-dimensional. To create a feeling of depth, the artist must create the highlights and shadows required to show the subject's form. Photographers, of course, must learn how to make the most of their lighting to accomplish this goal.

In this chapter and the next, we'll look at a variety of strategies that will help you achieve your lighting goals. Some of the information presented in chapter 7 will build on the information that follows, which is concerned mainly with using and modifying window light in the client's home.

HARD VS. SOFT LIGHT

Finding or creating the right quality of light is critical to creating a great portrait. In portraiture, we strive to avoid hard light sources. Hard light is direct light created by a source that is relatively small in size. It produces hard-edged shadows, bright colors, and bright highlights. Hard light that comes from above the subject (e.g., midday sun) is the worst offender, as it creates unflattering dark shadows under the subject's eyes and nose. (Though the sun itself is huge, its distance from the subject makes it small in relation to the subject.)

Keep in mind that you can modify or supplement hard light to produce more flattering effects. Of course, when working on location in the client's home, you can simply scout out a room with more flattering light, saving yourself time and energy.

Soft light is ideal for portraiture. Such light comes from a larger light source (e.g., a large window or a softbox). When the sun's position is just right (e.g., low in the sky, as it is from sunrise to an hour after sunrise and in the hour before the sun sets), it too can spill onto and caress your subject's features, rather than casting the harsh shadows produced at midday. No matter its source, soft light produces paler, softer shadows, and more subdued colors in your images. It can also enhance the appearance of your subject's skin and create a three-dimensional feel in an image. In the studio, photographers rely on softboxes, umbrellas, reflectors, and other devices to produce

soft, directional light. When working in the client's home, soft light generally comes from a large window. However, all window light is not created equal. We'll look at the qualities of good window light later in this chapter.

FINDING THE BEST LIGHT

When you arrive at the subject's house, look for great window light. In many homes, the master bedroom has a large window that can work well as your main light. The larger the light source, the more diffuse the light and the softer and more flattering the effect. A large window—10x5 feet in size and 3 feet from the ground—can be ideal. At this height, the natural falloff of the light can be used to your advantage, creating a darker area at the bottom of the image that will help to draw the viewer's eye to the subject.

Look for window light that softly illuminates the entire room. The light should come from the environment; in other words, be sure to avoid photographing a subject when the sun seems to be lined up with the window. Note, too, that the light should come from the side of the subject (not from a skylight or through a glass ceiling). This directional lighting will wrap around the

▶ **A HELPING HAND**

Though the best way to gauge the effects of a variety of window light scenarios would be to pose your subject near each window, this approach is not always practical. Using an assistant is your next best bet. Should you find yourself working solo, find a room where the sunlight softly illuminates the room. Open your hand and observe the way the light affects your palm. Move your hand around and observe the way the light changes. Where does the light most slowly transition from highlight to shadow? The best light will come from the side of the subject, wrap around, and fall off toward the bottom and far side of your subject. When the light has these qualities, it can be used to beautifully render your subject's form.

The beautiful light from a large living room window created a perfect place to work with this expecting mother and her toddler son. After moving through several poses and positions, this image was captured.

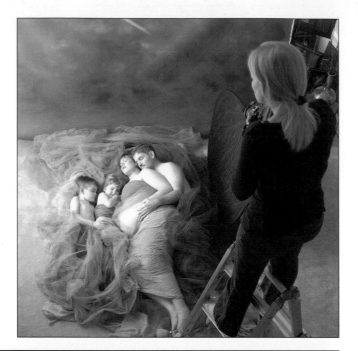

Left—As evidenced in this image, the lighting setup for this image was simple. **Facing page**—To create this particular image, a backdrop was hung, some fabrics were arranged on the floor, and the subjects were posed close to create a tender feeling in the image. A large window at camera left served as the main light, and a reflector placed to camera right helped to bounce light back onto the subjects, filling in the shadows.

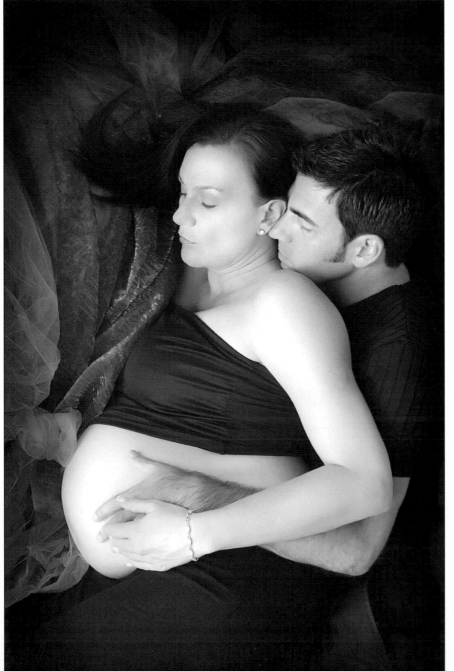

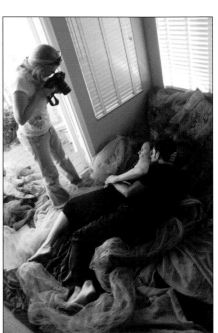

Left and right—Sometimes, giving the couple some basic instructions of where to lie, and then stepping away and not interfering, can lead to capturing a tender moment between them. This image was captured with a Nikon D2x at an ISO of 400 and a setting of f/3.8 at $1/60$ second. The image was retouched in Photoshop using the Healing Brush. The Kubota Artistic Actions Vol. Two Smoothner action and Kodak Digital GEM Airbrush Professional c. 2.0 plug-in were used to smooth out the skin. Finally, the image was vignetted using Kubota Artistic Actions Vol. Two Edge Burner action, and Nik's Midnight filter was applied.

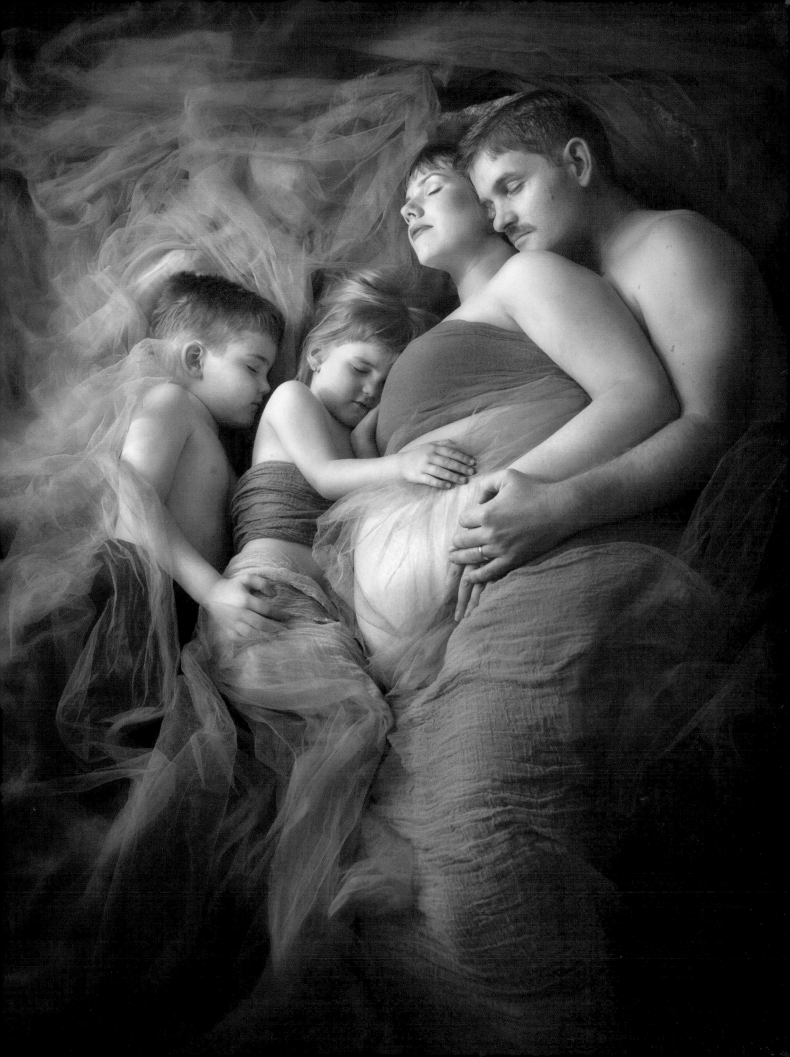

subject, creating depth and form, allowing you to achieve the desired three-dimensional quality in your portrait.

Light reflected by a white or light-colored structure more than 15 feet from the window can be ideal. This structure acts as a large reflector, pouring soft, diffuse light into the room. When working in a low-light situation, the photographer can place a large white reflector outside the window to simulate the same effect and thus direct more light into the working area.

Avoid sunlight that is reflected off of a parked car, the window of another building, or a metal structure. Colored objects outside the window (e.g., a house with blue vinyl siding) can affect the color of the light streaming into the room. Your best bet in such a case may be simply to find another room to shoot in. If this location is your best option, however, you can try to counteract the problem by using your camera's custom white balance setting and/or correcting the color cast in postproduction. Note that shooting in a second-floor room often improves the odds that your light will be free from the color casts that light can pick up from parked cars, grass, and other outdoor objects.

Once you've located the ideal window light source, position the camera at a 90-degree angle to the window. The subject should be 90 degrees from the camera angle, creating a triangle from the window, to the subject, to the camera. The subject then should have light falling on the side, not the front or back. A reflector or subtractive panel should be placed on the opposite side of the window with the subject in the middle. Again, be sure to avoid photographing the subject near a window when the sun is low in the sky and level with the window. This creates a hard light quality that will cast unwanted dark shadows on the subject's face.

▶ **MODIFYING THE LIGHT**

On a heavily overcast day, you may need to use a reflector outside the window to direct more light into the room and another on the opposite side of the subject to bounce light back onto her. On a bright and sunny day, you may need to use a diffusion panel in front of the window to soften the light falling on the subject for a more flattering effect.

It is common to have limited space in a traditional home setting. Standing on a ladder increased the distance between the camera and the subject. To create this beautifully lit image, the subject was posed facing the large master bedroom window, and the camera was positioned between her and the light source. Note that the positions of her arms create a graceful, visually pleasing S curve in the composition. A Fuji FinePix S3 Pro and an exposure of f/3.8 at $^{1}/_{180}$ second at ISO 400 was used to capture the image. Nik Software's Midnight filter was used to enhance the image postcapture.

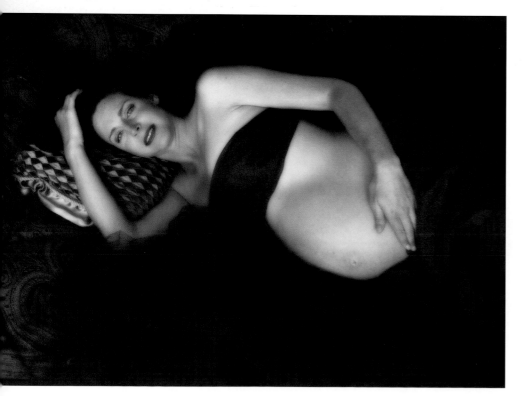

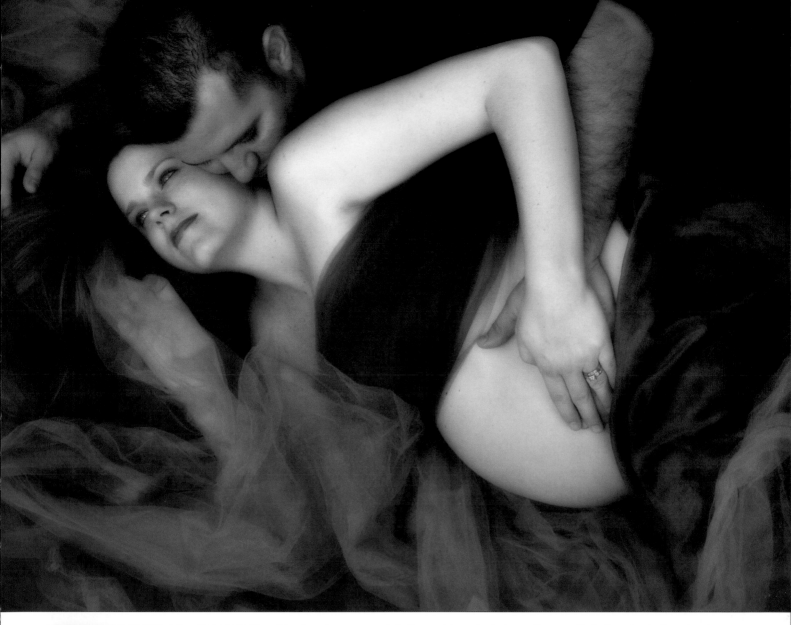

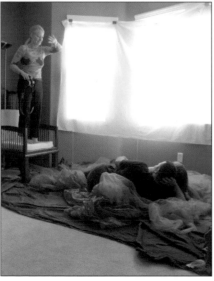

The above image was made in the couple's master bedroom. However, the bed was too far from the window and could not be moved. Therefore, the backdrop I'd selected for the session was placed on the carpeted floor, and complementary fabrics were added to enhance the color and add texture in the image. The light coming through the window was very bright, so diffusion cloth was hung over the window to soften the light. A reflector was placed directly across from the window. Note the direction of the light and how it wrapped around the couple.

When working with window or natural light, you will find that it is necessary to work at a faster ISO rating. Given the lack of space in most homes you will also have to use a shorter focal length lens (my Tamron 28–75mm f/2.8 lens worked perfectly in this situation). This image was captured with a Fuji FinePix S3 Pro camera, with an exposure setting of f/3.6 at $^1/_{90}$ second at ISO 400.

7. STUDIO LIGHTING

When conducting the pregnancy portrait session in the studio, you can create precisely the portrait lighting effect you're after. This is a clear advantage. Keep in mind that the best light is simple, soft, diffuse, and comes from the side of the subject, rather than from overhead.

When it comes to lighting a pregnant woman, your goal is to make her appear as beautiful as possible, to use lighting that helps her appear slim and shapely and caresses her features, making them as symmetrical as possible.

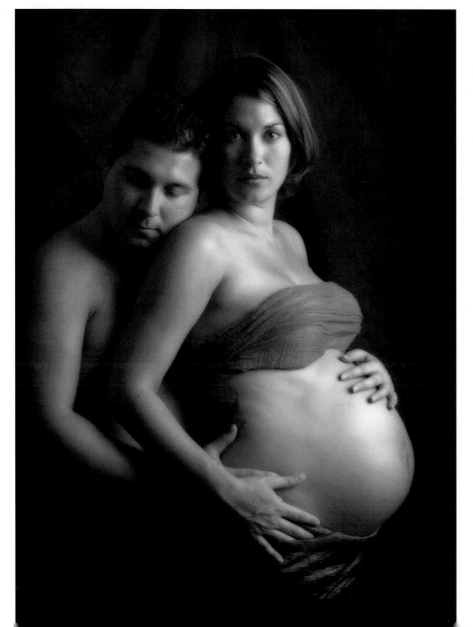

Above—Your main goal in studio lighting should be to create a sense of depth and dimension in the image. The lighting should be controlled in such a way as to illuminate and give form to the main subject. With a softbox, such as the Norman 60-inch octagonal softbox used in this image, the edge of the light falls off quickly, illuminating only the subject, not the surrounding area. The advantage of this is that the subject becomes the focal point. This simple setup consists of a Norman Monolight ML 400, a 60-inch octagonal softbox, and a black panel attached to a stand. **Left**—With striking subjects, you can use very dramatic lighting with a high ratio. This image was captured with a Nikon D2x and Tamron SP AF Aspherical XR Di LD 28–75mm f/2.8 lens. The setting was f/5.6 at $1/125$ second and an ISO of 100. The image was slightly retouched in Photoshop with the Healing Brush, then enhanced with Nik's Midnight filter. Finally, the image was vignetted using the Kubota Artistic Actions Vol. Two Edge Burner action.

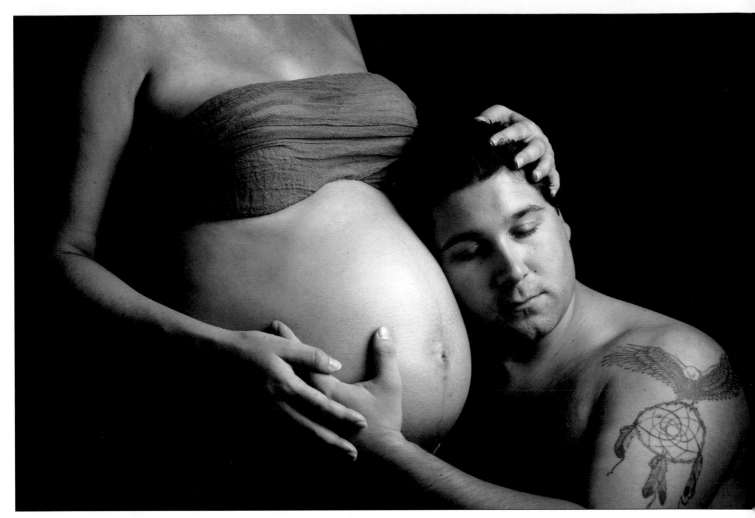

The dramatic lighting in this portrait was well suited to the subjects' personalities and helped to create the desired mood. Using a single softbox created the required shape and form across the mother's midsection and the father's face and arm. The father's position was reversed, as compared to the pose used in the facing-page image, in order to show his tattoo. The portrait is more interesting showing a piece of their personalities.

Using light that crosses the abdomen and falls off on the woman's backside, then turning her face back into the light can help to showcase her face to best effect and visually slim and flatter her figure.

THE TOOLBOX

Think of your camera room, and all the lighting equipment it contains, as your toolbox. When conceptualizing a portrait, determine the best tools for the job. Simple lighting is often best and can allow you to focus your attention on relaxing and complimenting your subject, finessing the pose, etc.

Your basic tools are your main light, fill light (secondary light used to lighten the shadow areas), light modifiers (softboxes, umbrellas, and other devices that fit over or on your lights), reflectors (white, silver, and gold), subtractive (black) lighting panels, light stands, backgrounds, and a light meter.

LIGHT RATIOS

To create the best-possible portrait, you must learn how to light your subject in a way that flatters her form. Often, a higher light ratio will be your best option.

A light ratio is a tool that photographers use to compare and describe the illumination levels (the highlight and shadow) produced on each side of the

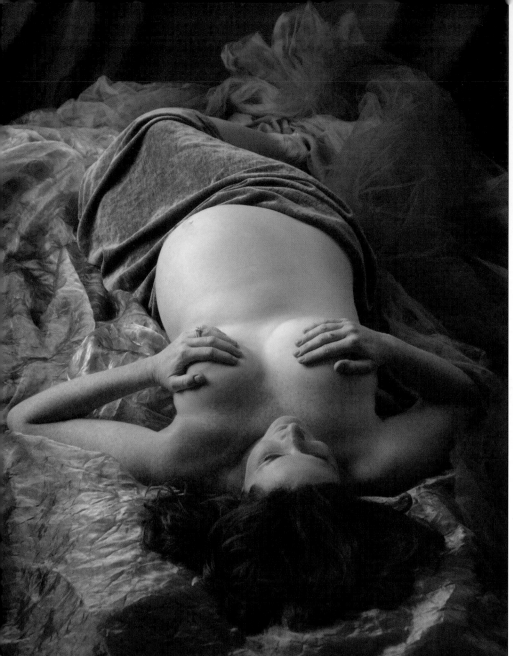

In order to give a beautiful form and shape to the subject and produce a three-dimensional effect, a higher lighting ratio was used to create this image. From the highlight side of the subject to the shadow side there was a 3-stop difference. The approach provided an added benefit of slimming the mother, with one side of her being in the shadow.

► **CLIENT TESTIMONIAL**

"Jennifer was such a pleasure to work with. My husband and I have never taken professional studio photos before. Jennifer made our experience very relaxing and was very understanding of our inexperience as photography models. She was able to explain the different lighting situations that were involved with each shot. She also had an upbeat attitude that made us comfortable to be around her and her camera. The photos were wonderful! We couldn't believe that it was us in the photographs. My husband and I loved every single photo she took and it was so hard to choose which was our favorite. We were very impressed by Jennifer's professionalism and her talent. She has a great eye."
—Celin T.

subject. The higher the ratio, the more dramatic the difference between the highlight and the shadow, and the greater the contrast in the image. When the subject is evenly illuminated, there is a 1:1 ratio. When the illumination is 2:1, the highlight side of the subject is twice as bright as the shadow side. In images with higher lighting ratios (e.g., 3:1), there is a more profound difference between the highlight and shadow areas. When the shadows are much darker than the highlights, the darker areas of the body seem to recede; in other words, the subject's form can be made to appear slimmer. Conversely, the highlights will draw the viewer's gaze.

In the studio, photographers use a flash meter to gauge the amount of light emitted by their strobes. In other settings, an incident light meter reading, with the dome of your meter pointed at the light source, can be used to determine the highlight to shadow ratio. (*Note:* In digital capture, care should be taken to not overexpose the highlights.)

BROAD AND SHORT LIGHTING

There are two basic types of portrait lighting: broad and short lighting. Broad lighting refers to a presentation in which the main light illuminates the side of the client's face that is turned toward the camera. This type of lighting tends to flatten the contours of the features and make the face appear wider. For this reason, it is not a favorable approach in the majority of sessions.

Short lighting refers to a presentation in which the main light illuminates the side of the face that is turned away from the camera. It emphasizes the contours of the subject's features and tends to present a more narrow view of the face. When a weak fill light is used in a short lighting setup, a dramatic lighting style with deep shadows and bright highlights results.

BASIC LIGHTING PATTERNS

Many photographers strive to achieve one of the following light patterns. These are tried-and-true "shortcuts" that can be used to flatter the face.

Butterfly Lighting. Butterfly lighting, also known as Paramount lighting, is a feminine lighting style that produces a butterfly-like shadow beneath the subject's nose. The lighting style emphasizes smooth skin and high cheekbones. To produce this lighting style, the main light is positioned high and in front of the client's nose. The fill light is placed directly beneath the main light, at the client's head height. Next, the hair light is placed opposite the main light. (Care should be taken to ensure that it lights only the hair and does not skim across the subject's face.) Finally, the background light is placed low and behind the subject to form a semicircle of light behind the subject that fades out toward the edges.

Loop Lighting. Loop lighting is a variation of butterfly lighting and is flattering for people with oval-shaped faces. To create this style of lighting, place the main light lower and more to the side of the subject so that the shadow under the nose becomes a small loop on the side of the face. The fill light should be placed on the opposite side of the camera, across from the main light, and close to the camera/subject axis. It's important to ensure that the fill light does not cast a shadow on the subject. The hair light and background light should be placed as described for the butterfly lighting portrait style.

Rembrandt Lighting. Also called 45-degree lighting, this portrait lighting style is characterized by its small, triangular highlight on the shadowed cheek of the subject. This is a dramatic lighting style that is often used when photographing male subjects.

To create this lighting style, place the main light lower and farther to the right than is described in the styles outlined above. Position the hair light as described in the loop lighting description, but move it in a bit closer to produce stronger highlights in the hair. The background light should also be placed as described above. However, the kicker lights should be positioned to add brilliant highlights to the outline of the face and shoulders. (*Note:* It is important to ensure that these lights do not shine into the lens.)

► **REMBRANDT LIGHTING**

Rembrandt lighting is a dramatic lighting style named after the famous painter, Rembrandt Harmenszoon Van Rijn. When painting his portrait subjects, Rembrandt used very directional light that came from a small open window above the subject. He allowed the light to fall across the subject, creating a small triangle of light on the far cheek under the eye. The resultant dramatic highlight-to-shadow ratio produced a feeling of depth in the portrait.

Split Lighting. The term split lighting is used to describe a lighting style in which the main light illuminates only half of the face. It's a dramatic lighting style that can be used to narrow wide faces or wide features and can be softened slightly when a weak fill is introduced.

To create this style, move the main light lower and farther to the side of the subject than it is used in the other lighting style descriptions. Sometimes, the light may be placed behind the subject. This placement may be necessary when the subject is turned far from the camera.

Profile Lighting. Also called rim lighting, this dramatic lighting style is used to emphasize a subject's elegant features. In this portrait style, the subject is turned 90 degrees from the lens. The main light is placed behind the subject to illuminate best the center of the profile and highlight the edge of the face, as well as the hair and neck. The fill light is placed on the same side of the subject as the main light, and a reflector is added opposite the main light to fill in the shadows. The background light is placed low and behind the subject. Adding a hair light is optional, but it can be placed on the reflector side of the subject for enhanced separation from the background.

SIMULATING WINDOW LIGHT

With window light, we strive to create a feeling of depth and form. Having light from a large window to the side of the subject travel across the body and fall away on the far side creates the form needed. With studio lighting, the goal should be the same.

Using one light and a reflector or black panel produces a lighting effect that is similar to window light but with a more abrupt falloff. The beauty of this is that the background falls into shadow, and the light is focused on the subject, drawing the viewer's gaze to the figure and emotion of the subject.

To create this family portrait, a 60-inch Norman octagonal softbox was placed at a 45 degree angle to the subjects and closer to the camera angle. A reflector was used opposite the main light. Shifting the light closer to the camera angle spread the light, illuminating all the subjects. With a larger group, be sure to move your main light to a position that covers everything. While this may flatten the light, all subjects will be lit and the light ratio will be sufficient to create form.

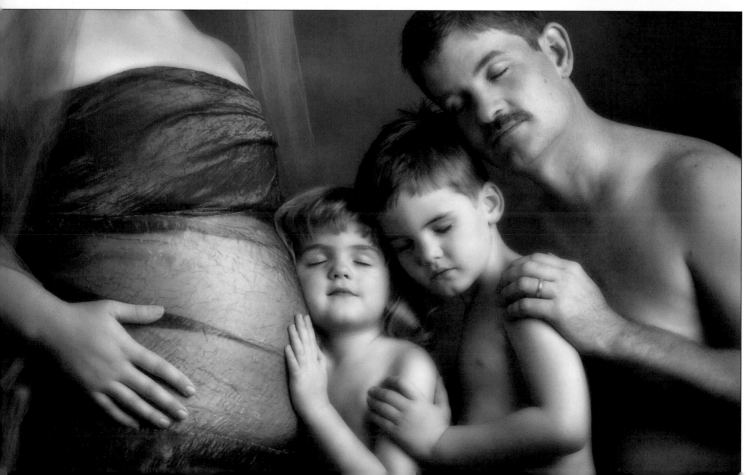

This shot was made following the creation of the couple shot shown on page 64. To set up the shot, the mom was moved into a seated pose, fabrics were added, and the softbox was lowered to center the mother in the light. This image was made with a Nikon D2x, Tamron 28–70mm lens, at f/5.6 and $^1/_{125}$ at an ISO of 100.

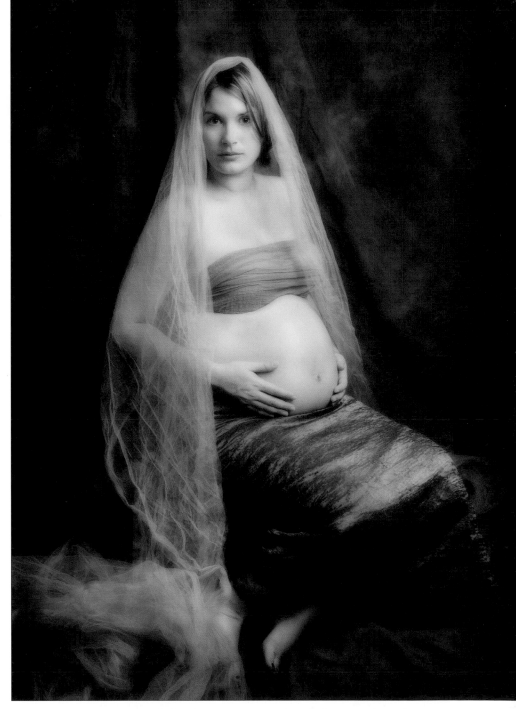

Another way to create light that mimics window light is to place the main light at a 45 degree angle to the camera, then add a small amount of fill light with either a reflector or strobe—or ambient light. This will give a lower ratio and less dramatic lighting, resulting in a softer, fuller look. This can be an especially good choice when photographing a family group.

To simulate window light, your light source will have to be up to four times wider than your subject (e.g., one that is at least 4 feet in width, but ideally, 5–6 feet wide). Position the light to the side of the subject with a reflector or black panel on the opposite side. The camera angle will be from the front of the subject, placing it at 90 degrees from the light and subject. This lighting setup will give you the most dramatic lighting, with high lighting ratios, creating form and depth.

8. RETOUCHING AND CREATIVE EFFECTS

The digital age has changed photography forever. It is now easier than ever to smooth out problems that might cause some pregnant women to shy away from the camera. We can use Photoshop's Healing Brush to refine the client's skin, removing blemishes that result from hormonal changes and removing veins and other perceived flaws. We can use the Liquify filter to slightly reshape areas that need a little finessing. By combining the power of

Left—After slightly retouching the image with the Healing Brush, the Nik Midnight filter was applied. **Right**—A touching moment can be best represented by a simple black & white image. Once this image was converted to black & white, the Nik Midnight filter was added.

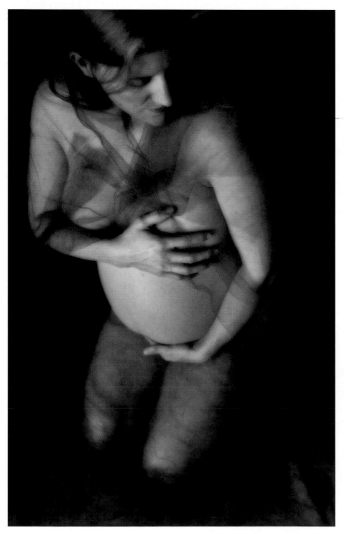 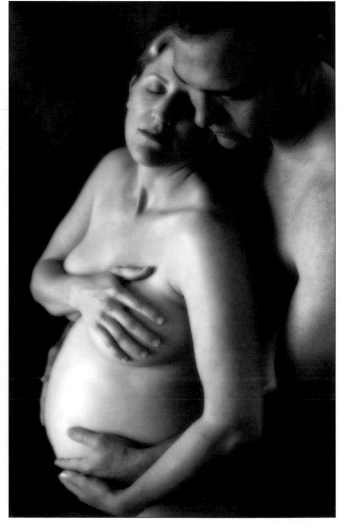

Top—When starting to retouch an image, open your raw file and make adjustments to the color balance and exposure. Copy the corrected image, then continue to work on the copy. **Bottom**— Most digital images will need sharpening. This image was sharpened in nik Sharpener Pro 2.0. Size and resolution settings were selected, and the file was prepared for lab output.

Photoshop with the wide range of dazzling effects available through the use of Photoshop plug-ins, we can use our artistic talents and imagination to create unexpected fantasy images.

In the sections that follow, we'll take a look at how a variety of images were digitally retouched and enhanced in postproduction.

BASIC RETOUCHING OF SKIN

Digital images normally need some type of retouching, from a small amount of sharpening to resizing the image. Below, the basic approach to retouching will be demonstrated in several steps.

1. In Photoshop, open the original image, then duplicate the background layer (Layer>Duplicate Layer). If necessary, sharpen your image first, flatten the layer (Layer>Flatten Image), then create a new duplicate layer and proceed to step 2.
2. Now, we'll use the Healing Brush to remove blemishes, veins, and stretch marks. Using a small brush, select an area with the same skin tones and

lighting as the area to be retouched. Use the Alt/Opt key to select the unblemished area, then click over the blemish area to remove it. The Healing Brush matches the texture and lighting of the sampled area, giving the blemished area a natural look.

The original image, before retouching the under-eye area.

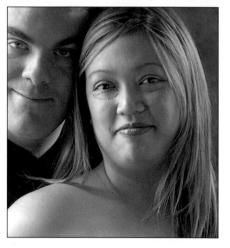 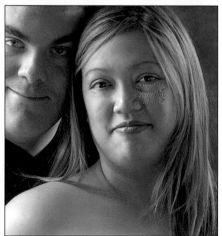

The affected areas were selected using the Patch tool.

By sliding the selected areas down to an area with smoother skin, we were able to improve the portrait.

3. To remove or soften bags under the eyes, duplicate the layer. Using the Patch tool, select the affected under-eye area. With the selection made, move the selection down to an area with smooth skin.

4. With the selection still active, lower the opacity of the layer to around 40–60%, depending upon what gives a more natural look to the eyes. Then flatten the image (Layer>Flatten Image).

DIGITAL SLIMMING

The liquify filter is a wonderful tool that can be used to slightly slim the arms, under the chin, and along the body line. Here's how it's done:

1. In Photoshop, go to Filter>Liquify. (Make sure you are working on a flattened image.)

2. Using a very large brush, select the Forward Warp tool and carefully nudge along the length of the arm to slightly slim it. Moving to the inside of the arm, reduce the size of the brush and nudge along the inside of the arm.

3. Using the Pucker tool, gently reduce the area under the chin, along the chin line, and at the cheek area. Go slow and keep an eye on your results, backing up if the correction does not look natural.

Top—The liquify filter was chosen, and a large brush was used to nudge along the length of the arm. **Bottom left and right**—Next, the Pucker tool was used to slightly slim under and around the chin and in the cheek area.

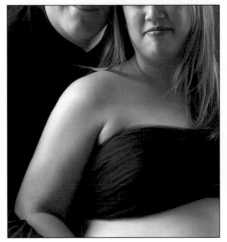

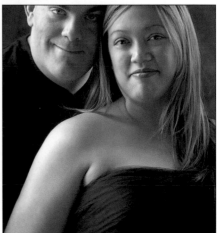

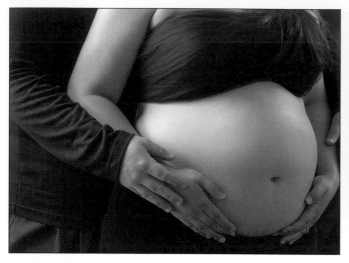
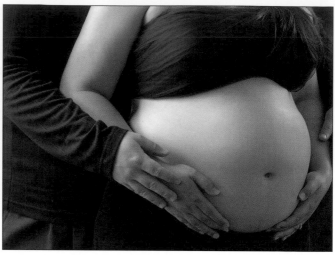

4. Moving to the midsection, you can create the illusion of a slimmer subject by putting a little more curve in the back. Using the Forward Warp tool again, slightly push the curve of the back in.

5. To further give the impression of a slimmer midsection, take the Pucker tool and the Forward Warp tool to the other side of the tummy and gently push in the edges.

Left—The forward warp tool was used to put a little more curve in the back for a slimmer appearance. **Right**—The Pucker tool and Forward Warp tool were used on the other side of the tummy to slightly slim and enhance the body line.

Once the subject is retouched, you can further enhance the image using Nik Software's Midnight filter, as demonstrated below.

NIK SOFTWARE'S MIDNIGHT FILTER

Creating portraits reminiscent of paintings is very easy with Nik's Midnight filter, found in the Nik Color Efex 2.0 Stylizing Filter set. The filter softens the edges in the image, darkens shadow areas, and lightens highlights. With the right image, the filter can be a perfect creative tool for creating a romantic, moody effect.

With the filter's contrast-altering qualities in mind, the original image was created using a lighting ratio of 3:1, rather than the 5:1 ratio I typically favor

This screen shot shows the original image and the effect of applying the Midnight filter.

for pregnancy portraits. The image was lighter than usual, with both the subject and surrounding area well illuminated.

Once installed, the Nik filters can be accessed via Photoshop's Filter menu. To create the final image, the following steps were employed:

1. In Photoshop, the background layer of the original image was duplicated (Layer>Duplicate Layer).
2. With the duplicate layer active, the Midnight filter was selected (Filter>nik Color Efex Pro 2.0: Sylizing Filters>Midnight filter).
3. In Nik's Basic palette, the following slider amounts were set: Blur = 40%, Contrast = 15%, Brightness = 100%, and Color = 100%.
4. The Protect Highlights slider and Protect Shadows slider were both set to 50%.
5. With the settings in place, I clicked OK.
6. When the effect was complete, the image layers were merged (Layer>Flatten Image) and the image was saved and closed.

The final image. Note the Midnight filter's effect on the highlights and shadows in the image.

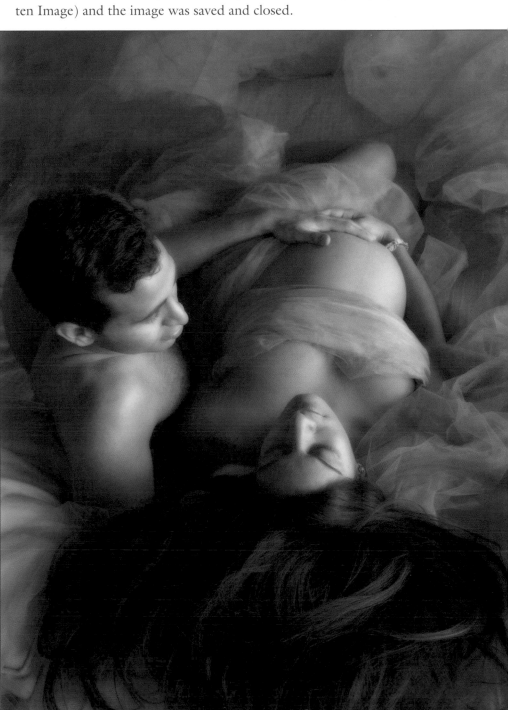

Though the entirety of the image shown here was treated with the Midnight filter, you can use the settings in the Nik Selective palette to selectively apply the effect. To do so, you can apply the effect to the overall image, as outlined above, then use the Erase tool in the Selective palette. To do so, choose the Erase mode, select a suitable brush size in Photoshop's Options bar, reduce the tool's opacity, paint over areas that should appear slightly lighter and sharper (e.g., the eyes and the highlights in the hair), and hit Apply. Alternatively, you can simply select the Midnight filter from the Selective palette, adjust all of the sliders in the Basic and Advanced palette as desired (see steps 3 and 4 above) and then click on the Paint button to selectively add the filter to specific image areas. When the image appears as you desire, hit Apply. For the majority of the images in this book, the entire image was covered except for the eyes, lips, and sometimes hair.

BASIC RETOUCHING AND ENHANCEMENT

The steps below illustrate how making a few refinements to this touching family portrait made for a more attractive and salable image. You can employ these techniques to correct similar problems in your own images. *Note:* Be sure to save a backup copy of all of your images before retouching them so that you always have an original file to revert to should the need arise.

1. To remove the visible veins and blemishes from the mother's stomach, the background layer was duplicated (Layer>Duplicate Layer).
2. Next, the Healing Brush was used to retouch the stomach area.
3. The Clone tool, with an opacity setting of 100% was selected next, and skin was sampled and stamped over the visible portion of the girl's shorts. Note that this tool can also be used to extend the background area if need be and to add more fabric to better cover the body (or stamp skin tones over some clothing that's peeking out from under a tulle wrap).

This screen shot shows two images—the final portrait (left) once the retouching was complete and the filter effect was applied, and the original (right).

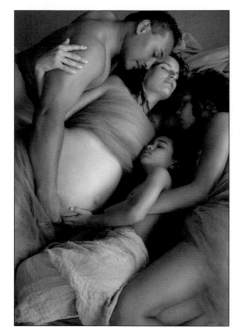 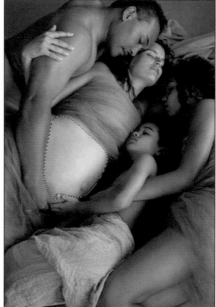 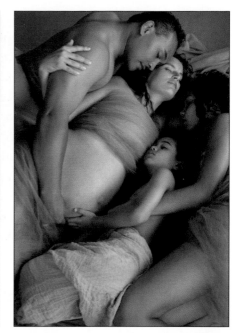

Top—(Left) The Healing Brush was used to re-touch the subject's stomach area. (Center) The mother's stomach was selected with the Lasso tool. (Right) A layer mask was created to isolate the woman's stomach. **Bottom**—This screen shot shows the Nik Midnight filter Basic palette and the settings chosen for this image.

4. The stretching of the skin across the pregnant mother's midsection re-sulted in a slightly lighter skin tone in this area. To solve this problem, the stomach area was isolated with the Lasso tool. With the selection active, I clicked on the Layer Mask icon at the bottom of the Layers palette and changed the blending mode to Multiply. The layer opacity was reduced to 57% to ensure that the stomach area matched the rest of the woman's skin.

5. The layers were merged (Layer>Flatten image), and a new duplicate layer (Layer>Duplicate Layer) was created.

6. The last step was to enhance the new duplicate layer with Nik Software's Midnight filter. To create this image, settings of Blur = 51%, Contrast = 52%, Brightness = 98%, and Color = 89% were selected in the Basic filter palette. If you desire, you can use the Advanced palette (accessed by click-ing Advanced at the top-left corner of the Basic palette) to specify the de-gree to which the image highlights and shadows will be protected when

the filter is applied. For this image, those values were Protect Highlights = 50% and Protect Shadows = 20%. Next, I clicked OK to apply the filter.

7. With the desired effects in place, the image was flattened (Layer>Flatten Image) and saved.

NIK'S MONDAY MORNING FILTER

Nik's Monday Morning filter (also available in the Nik Color Efex Pro 2.0 filter set) is another great option for finishing an image. The following technique is courtesy of Patricia Mathis, who is also the model in the image!

1. Patricia accessed Nik's Monday Morning filter through Photoshop's Filter menu. In the Basic palette, the sliders were adjusted as follows: Grain = 0%, Brightness = 28%, Smear = 63%, and Color = 100%.

2. Next, she clicked on the Advanced setting in the upper-left corner of the palette. The Protect Highlights slider was set to 100%; the Protect Shadows slider was set to 47%. She hit OK to apply the filter effect.

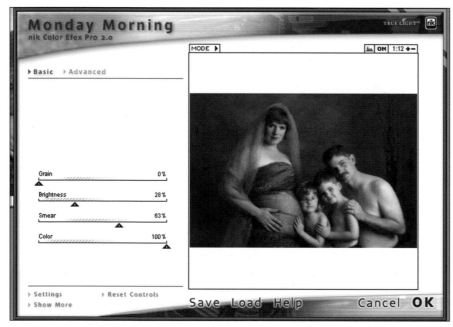

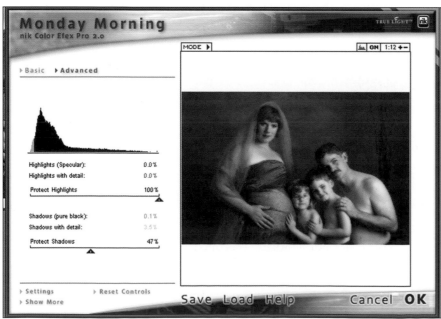

Top—This screen shot shows the Basic palette for the Monday Morning filter and the settings used to create the final effect. Note that the orange highlight above the sliders indicates the range of values that will work best with the particular image. **Bottom**—This screen shot shows the Advanced palette and the Protect Highlights and Protect Shadows values used to create this image.

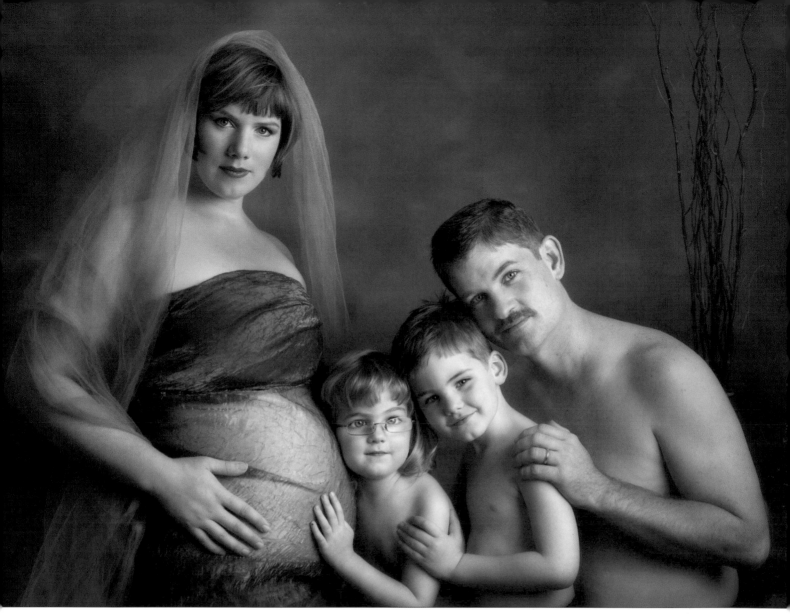

Here's the final image, beautifully rendered by Nik's Monday Morning filter.

3. Patricia then created a layer mask, exposing only the eyes. She chose the Erase mode, selected a suitable brush size in Photoshop's Options bar, and set the tool's opacity to 35% to bring back some of the sharpness in the eyes. Next, she used the same opacity setting but chose a larger brush size to bring back some sharpness in the face. Finally, she enlarged her brush and erased areas around the subjects' heads to make those areas a little sharper.

BORDER EFFECTS

Compositing a pregnancy portrait with an image of an artistic border is a quick and easy way to change the mood and overall impact of an image. This is one of the easiest effects to achieve, and one of the most beautiful treatments. Here's how it's done:

1. First, we opened our beautiful natural-light maternity image in Photoshop.
2. Next, the stock border image (courtesy of Mercury Megaloudis, a prominent Australian photographer) was opened.

Top—To composite a portrait with an artistic border photo, first open both image files in Photoshop. **Bottom**—A layer mask is created on the border image layer, and the portrait, which lies just below the border image, is revealed. **Facing page**—Here is the final composite pregnancy portrait.

3. The border image was pulled on top of the pregnancy portrait and resized using the Edit>Transform function to ensure that it matched the dimensions of the pregnancy portrait.

4. The Eraser tool was used at several different opacity settings to blend the border into the image. The opacity from the outside of the border into the image was increased so that the border overlapping the image was almost completely erased.

FANTASY IMAGES

For expectant parents, a sonogram provides an exciting opportunity to "preview" the baby in the womb. Through the technological advances that digital imaging offers, photographers can now help clients to preserve the magical feeling that comes from catching a glimpse of the baby in the uterus. You can use the process outlined below to create a composite portrait that super-

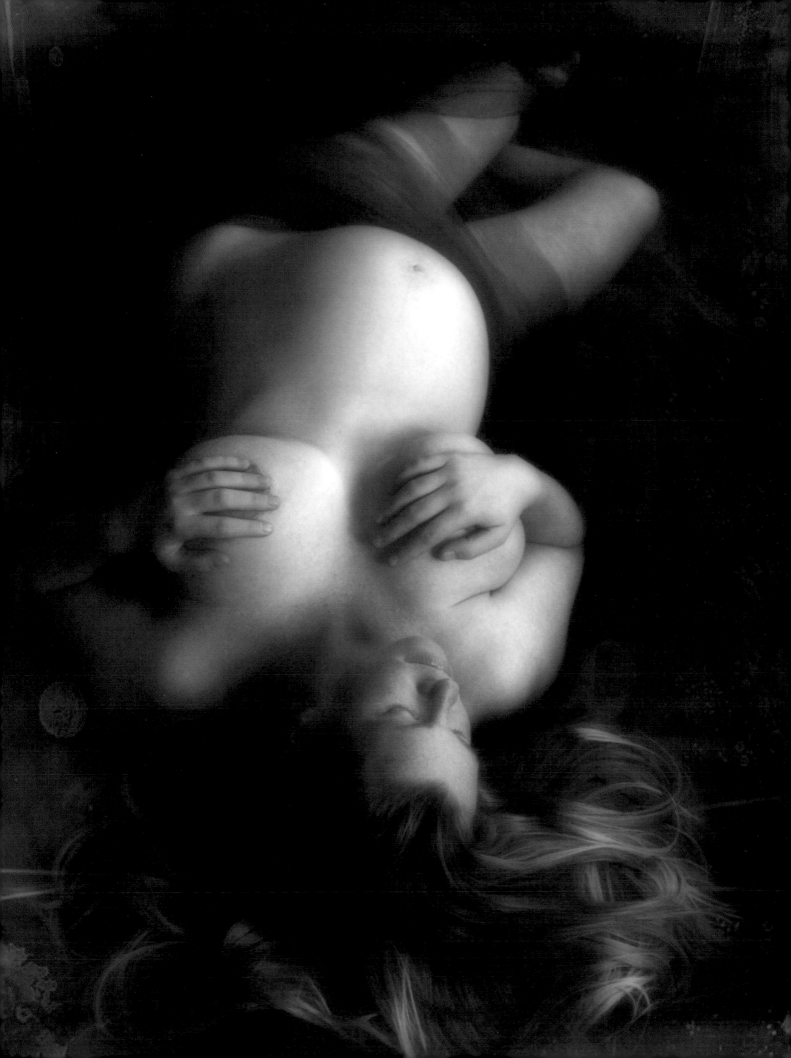

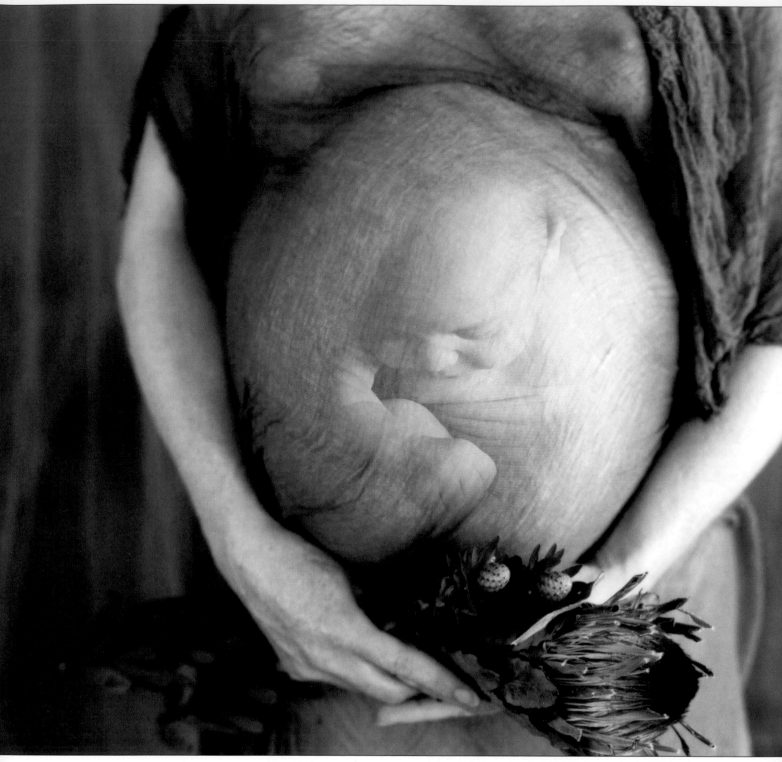

imposes an image of the baby onto the mother's stomach, creating a fantasy portrait that's highly desirable to your clients.

Photographing the Belly. When photographing the mother's belly, be sure to capture it at its widest point. Depending upon how the mother is carrying, this usually is from the front, but in the case of the twins, the best angle may be from the side. The lighting should illuminate the main portion of the belly but should not be so intense that detail is lost in the highlights.

Many new parents cherish composite photos. Creating them involves importing the newborn baby's photo into Photoshop and working a little digital magic.

It is important to hold the texture of the skin, as this will add to the realistic feel of the image. Lighting from the side of the subject and using a lighting ratio of 3:1 or greater will help you sculpt the subject's figure and enhance the feeling of dimension in the image.

When creating an image to be used in a composite like this, take care that the mom's hands and any props do not cut into the view of the tummy. This will facilitate compositing the images in Photoshop. There is one notable exception to this rule: it can be a good idea to cover the belly with a sheer, almost transparent fabric. The fabric layer adds to the natural transition between the belly and the baby. Without the fabric, it can be difficult to achieve a smooth transition, and the image may end up looking too contrived.

Photographing the Baby. The second component of the fantasy image is the newborn portrait. Portraits of babies who are six days to three weeks old seem to work best. At this age, the babies can be easily brought into the studio. Also, by this time, the mom and baby will have an established and ef-

Creating this "twins in the womb" portrait was fairly easy. We started with a portrait that allowed for an unobstructed view of the shape of the tummy and then created a portrait of the twins nestled closely as they would have been in the uterus. To ensure the best-possible effect when creating an image like this, you will want to capture the pregnancy at the latest date possible so the tummy size appears appropriate for a full-term baby (or babies). The timing can be tricky: in this case, the session was held four weeks before the due date, since twins traditionally come early. As it turned out, this mother went into labor immediately after the session.

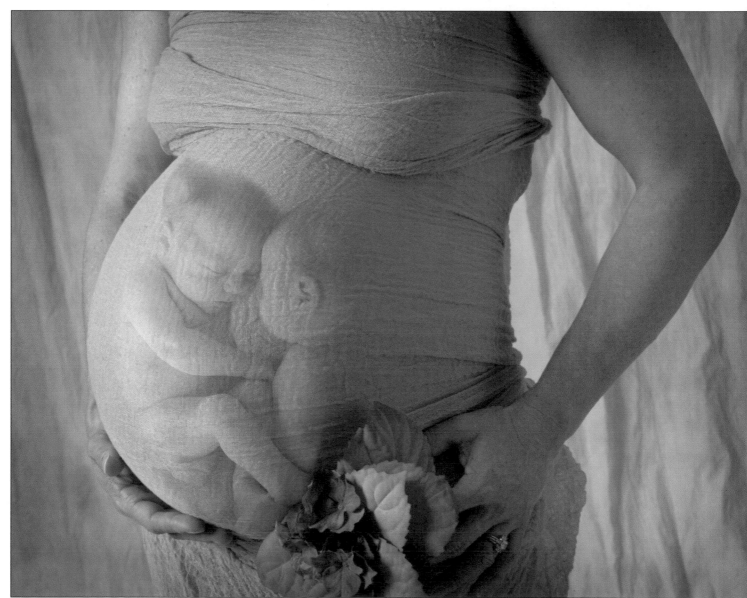

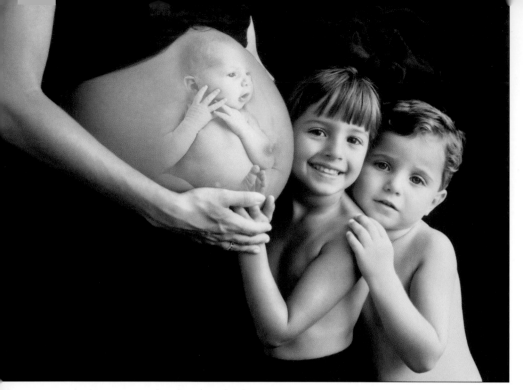

Though sleeping babies usually appear more realistic when digitally imposed on the mommy's tummy, there are times when an expression works perfectly with the mood of the image. Here, the baby's expression works well with the older siblings' expressions. Additionally, the little hands of the baby, positioned close to the face, harmonize with the hands of the mom and siblings.

fective feeding pattern; this can help ensure the baby is calm, and sleepy, for the image. A sleeping baby appears more like a baby in the womb.

The fabrics used in the pregnancy session will help you determine which fabrics to photograph the infant against. Try to photograph the baby against a fabric that matches the mother's skin tone as closely as possible for easier blending once the images are combined.

The easiest way to photograph the baby is to place the background fabric over the mother, then place the newborn in her arms. Have the mother curl the baby into a tight little ball, simulating the way the baby would appear in the womb. Take several images from various angles. If possible, ensure that the quality and direction of the light used in the pregnancy portrait is re-created in the image of the baby. If this is not possible, you may be able to flip the image in Photoshop or do a little image editing to ensure the two images are better matched.

In the following sections, we will review the specific strategies used to create composites.

Baby Makes Three

The portrait of the father and mother was captured at the client's home approximately one month before the baby was born. The image of the newborn was captured about ten days after birth. To create the newborn's portrait, we draped the mother in fabric and placed the baby in her arms.

1. Both images were opened in Photoshop.
2. A duplicate layer (Layer>Duplicate Layer) was created, and some minor retouching was done.
3. The varied skin tones of these three subjects made the image a good candidate for a color to black & white conversion. To accomplish this, the

image was flattened (Layer>Flatten Image), then the Kubota Artistic Actions Vol. Two New B&W action was selected in the Actions palette, and the effect was applied by hitting the Play button.

4. The image of the baby was flattened and resized to suit the size of the mom's stomach. The portrait was dragged above the layer containing the pregnancy portrait. Next, the Eraser tool, set to various opacities, was used to erase the fabric the baby was photographed upon. The baby was moved into the desired position on the belly. Note how well the position of the baby complements the position of the father's face and expression.

5. The background layer was renamed Layer 0 to unlock it so that the layer with the baby could be dragged below the pregnancy portrait layer. A layer mask was created on the pregnancy portrait layer, and with the Brush tool set to black and with an opacity of 73%, the baby was revealed. (*Hint:* Take care to reveal only what is needed to tell the story of the image.)

6. Finally, the image was flattened (Layer>Flatten Image), then the Kubota Artistic Actions Vol. Two Edge Burner action was selected in the Actions palette, and the effect was applied by hitting the Play button.

Left—This screen shot shows the two images that will be composited and finessed to create the fantasy image. **Right**—This screen shot shows the image of the baby positioned on the mother's tummy.

Left—A layer mask was created, and the Brush tool, set to black and an opacity setting of 73%, was used to reveal the image of the baby. **Right**—Adding a vignette with the Edge Burner action was the final step required in producing this fantasy portrait.

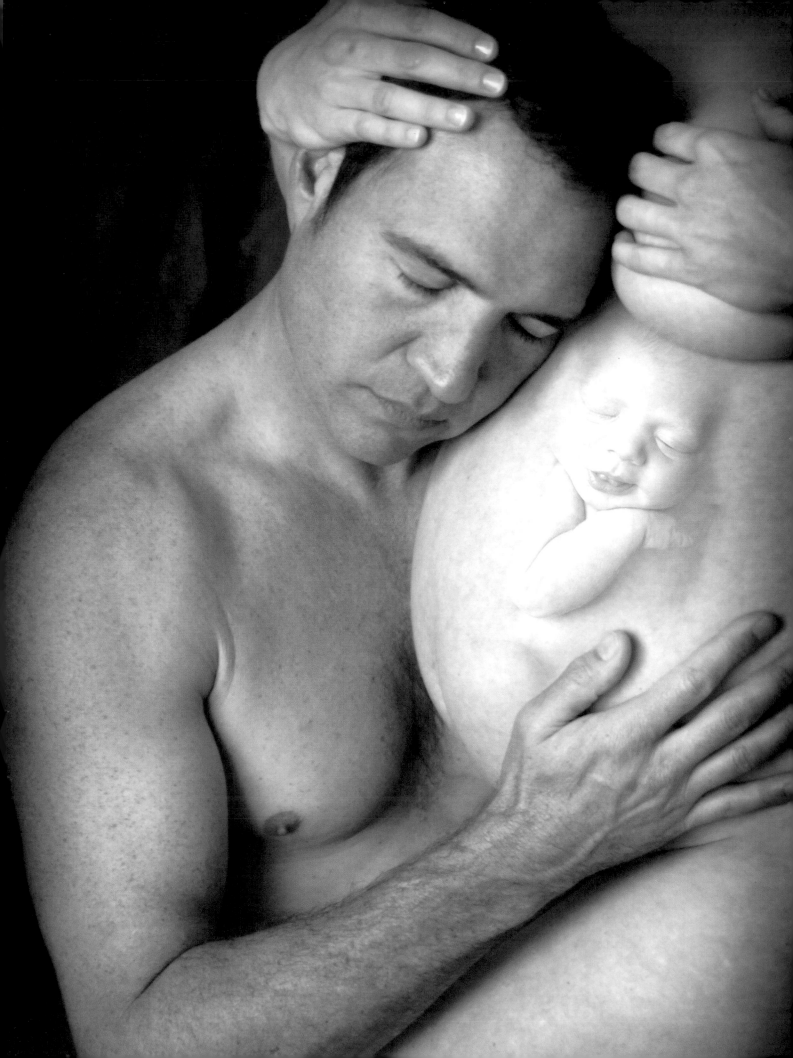

Twins

The maternity portrait showcased in this section was captured late in the pregnancy. Given the size of the mom's belly from carrying twins, it was necessary to cover her tummy with fabric. After investigating several positions, she was photographed from above with light coming from a window directly in front of her.

The twins were photographed in their home less than three weeks after they were born. Some babies can become very fussy during the session. Having their mother hold them can be a problem, as they may want to nurse if they sense that Mom is nearby. Faced with this situation during this session, we had their grandmother sit down near a large window in the home and covered her with a white backdrop. When the babies were asleep, they were positioned very close together and photographed on grandma's lap.

Both images were imported into Photoshop, and the following steps were taken to produce the composite fantasy image.

1. Both images were opened in Photoshop.
2. The image of the babies was cropped, dragged over the pregnancy portrait, and positioned on the mother's belly. The edges of the fabric around the

Facing page—The final composite image. **Top—** First, both images were opened in Photoshop. **Bottom—**The image of the twins was dragged onto the photo of the mom, and the babies were positioned on their mom's tummy.

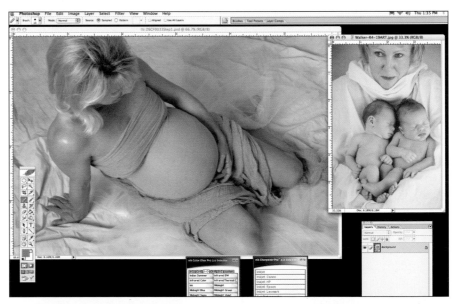

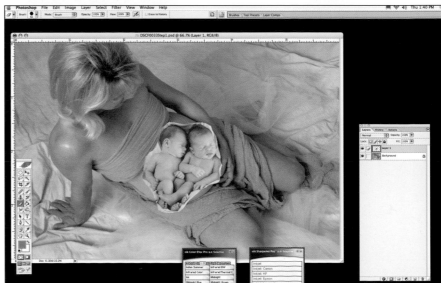

Top—This screen shot shows the appearance of the Layers palette, illustrating the steps applied in step 3. **Bottom**—(Left) This screen shot shows the Protect Highlights and Protect Shadows values selected in the filter's Advanced palette. (Right) This screen shot shows the Grain, Brightness, Smear, and color values assigned in the filter's Basic palette to create the final filter effect.

babies was erased using different opacity settings to create a realistic transition from the fabric under the babies to the mother's skin.

3. The layers were renamed, and the layer containing the image of the babies was dragged below the pregnancy portrait layer. A layer mask was applied, and the Eraser tool, set to various opacity settings, was used to reveal the image of the twins and to blend the areas where the two images met to create a realistic transition.

4. Next, the image was darkened slightly in Levels, and hot spots were retouched with the Clone tool.

5. The Monday Morning filter was opened. In the Advanced palette, Protect Highlights was set to 100% and Protect Shadows was set to about 50%. In the Basic palette, the slider settings for this filter were Grain = 0%, Brightness = 30%, Smear = 38% (this falls within the highlighted area of the slider, indicating the range of values that will produce the best effects for the selected image), and Color = 100%. With these settings in place, clicking OK applied the filter.

6. Next, the image was flattened (Layer>Flatten Image). To finish the portrait, Kubota Artistic Actions Vol. Two Edge Burner action was used. To apply the effect, we simply selected the action in the Actions palette and hit Play.

Top—The Kubota Edge Burner plug-in was used to create a vignette around the subject, which helps to draw the viewer's gaze to the focal point of the image. **Bottom**—The final image.

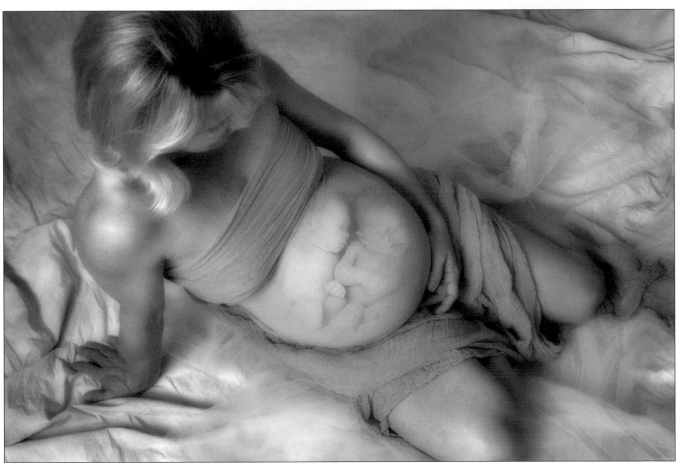

9. MARKETING AND SALES

Many photographers have a tendency to get so caught up in the art of creating their images that they neglect to devote their time and energy to marketing their unique brand of portraiture and enhancing their sales. This chapter will provide some easy-to-implement strategies to help you meet those goals.

MARKETING IS ESSENTIAL TO SUCCESS

With a limited audience of expectant mothers, marketing is essential to your success as a pregnancy portrait photographer. Reaching that audience and enticing them to purchase your products and services is key. Just having beautiful images of pregnant mothers will not be enough to draw business. In the article "Power Selling," Mitche Graf seconds that notion, saying, "Many photographers are incredible at creating stunning images for their clients and win all sorts of awards from their peers for their technical and artistic expertise. But without the ability to sell themselves or promote their business, failure is not far behind. Long gone are the days when you could hang out a shingle and people would flood to your studio simply because you were good. In today's fiercely competitive field of professional photography, only the strong will survive and the weak shall perish. Which will you be?" (*Rangefinder*, March 2004).

The goal of this chapter is to provide several ideas for getting the word out about your specialty. As you will see, creating the marketing piece—be it a brochure, business card, or postcard—is only half the challenge. Finding the right location at which to display your marketing pieces or a mailing list that will allow you to target prospective clients is key to your success.

YOUR IMAGE

The first step to success in marketing is presenting your work, studio, and yourself in a cohesive manner. Your work, studio, and professional appearance should send a message to prospective clients and entice your desired demographic. When looking at your body of photographic work, what words come to mind? Is your work traditional, young and fresh, edgy and modern, or calm and romantic? If you can't come up with descriptive words that describe

▶ **SAGE ADVICE**

Mitche Grafe says, "Marketing is a tool, not a magic pill, a cure-all, or a secret potion. It takes hard work. Some photographers need to be reminded that the camera is also a tool to get what we want out of life" (as quoted in CharMaine Beleele, "Power Marketing Super Conference." *Rangefinder*, Feb. 2005).

Your business cards should mirror the style and quality of your other marketing materials and should appeal to the demographic you're after. Business cards created by Studio2CDesign (www.studio2Cdesign.com).

the type and style of your work, show a selection of your images to others and listen to what they say. Do your studio and appearance reflect the feel of your portrait style? The look or feel you create is considered "branding." To sculpt your image, consider the following questions: What sets you apart from your competitors? What message do you want to send to the public? Why should a mother come to you, rather than another photographer, for her maternity portraits? Bill Chiaravalle and Barbara Findlay Schenck's book, *Branding for Dummies* (Wiley Publishing, 2006) is a great resource for developing your business image. *Power Marketing* by Mitche Graf (Amherst Media, 2004) is another indispensible book. On the Internet, be sure to check out www.smallbusinessbranding.com for information on sculpting your image.

Once you have a handle on what your style is, or what you want it to be, you will want to ensure the colors, font styles, and even the size of the pieces you create reflect that style. If your style is traditional, you will want to select standard-size postcards, subdued colors, and brochures and with classic fonts. If your look is young and fresh, you will want to use odd-size postcards, bright colors, and funky fonts. Keep the look cohesive and follow the color, style, and feel throughout all your marketing pieces, including your website.

BROCHURES AND FLYERS

Many photographers drum up interest in their pregnancy portraiture by placing colorful, eye-catching brochures and flyers in local obstetricians' and pediatricians' offices. Your brochures and flyers should feature your best work and should be updated often with new images.

When designing these materials, be sure that the text does not overshadow the focal point of the marketing piece—your photography. Also, be sure that your contact information (studio name, address, phone number, and website) are prominently featured. Also, strive to create a brand identity. In other words, select a font and overall layout that remains consistent from one piece to another. Also remember to ensure that your print materials are top quality. They represent you, your studio, your work, and your professionalism. If you are not confident in your ability to design your own marketing materials, hire a professional designer. Quality is key. Remember, your portraits may be award winning, but if your marketing materials don't reflect that professionalism, prospective clients won't pursue you as their photographer.

POSTCARDS

If you distribute postcards, make them colorful and eye-catching. Say little, show a lot! Make them tiny masterpieces. The same design elements can be incorporated in print newspaper and magazine ads and television ads; this will help you to build brand recognition.

The priceless expressions and the rounded tummy featured on this postcard will appeal to a wide range of prospective clients. Frequently update your postcards and other marketing materials so that the image shown represents your current style. Postcard by Studio2CDesign (www.studio2C design.com).

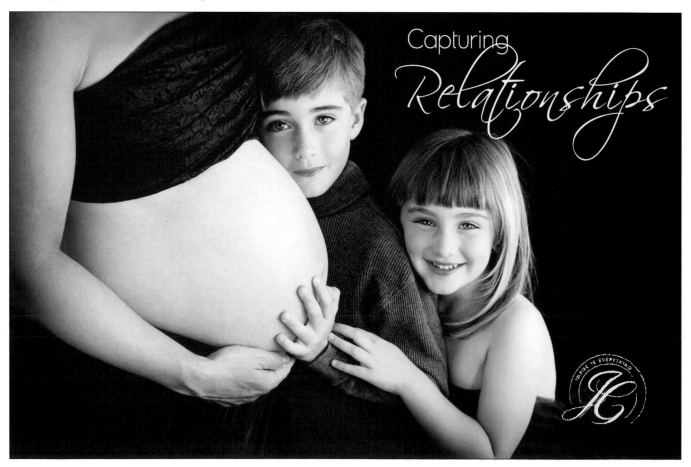

Beautiful children and mothers make good subjects for marketing pieces. Here, the colored fabric behind the mother and child helps to catch the eye of the viewer.

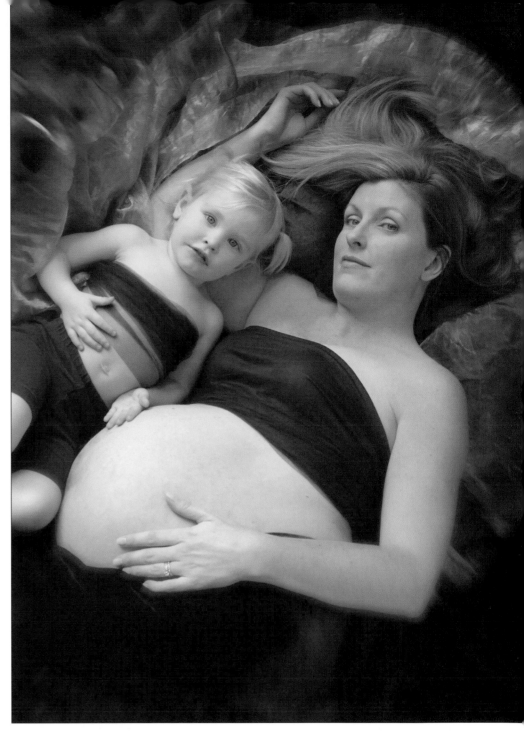

Mail the postcards to newlywed clients—or to all of your clients. You can also mail them to local residents if your budget allows. Smaller studios and more frugal owners may find that they can generate all of the business they can handle simply by leaving the postcards in doctors' offices, in baby furniture and clothing stores, in maternity shops, on laundromat bulletin boards, in teachers' lounges at schools, in child pickup areas at preschools, at La Leche League meetings by the refreshments table, on bulletin boards in stores near the photo supplies or baby items, in the "quiet room" where babies are taken during church services, at elementary school resource centers, etc. Purchasing a mailing list can simplify your marketing strategy. One good source for such lists is www.listservicedirect.com.

With the ability to order high-quality postcards online at reasonable prices and small quantities, you can afford to change the images on the postcards frequently.

NEWSPAPER AND MAGAZINE ADS

If you advertise in newspapers, family magazines, or weekly speciality papers, be sure to purchase an advertisement large enough to draw attention, and run the ad consistently (e.g., every Monday, Wednesday, and Friday, for several weeks). Consider including a coupon for a free sitting in the parents' magazines and newspapers for your area. You will have a way to gauge your exposure by the number of coupons redeemed.

If your budget prohibits the purchase of newspaper or magazine advertising, consider offering to photograph a few local events in exchange for advertising space. Many small-town newspapers are understaffed and would welcome your offer to lend a hand. Amy Connor, a successful San Diego–area photographer has had success with this approach. She worked with her local newspaper, taking photos in her community to supplement their news coverage, and the newspaper ran her studio's ad. Amy said of the experience, "It not only opened the community's eyes to my work but also continually got my name out in front of a whole new audience of potential clients."

If advertising seems like a lot of work, remember the words of Edward Weston ("Shall I Turn Professional?" *American Photography* 6 [Nov. 1912], 620–24): "Photography to the amateur is recreation; to the professional it is work and hard work too, no matter how pleasurable it may be." Producing artistic, sensational photographs and soliciting clients to photograph is hard work. You must develop a good marketing strategy and must devote a great deal of attention to efficiently carrying it out.

YOUR WEBSITE

A website is a critical component of an effective marketing plan, and having one is just as important as having a business card. Anyone with expendable income will likely have access to a computer—and, of course, anyone with expendable income may be willing to spend that cash on your services.

A photographer's website is a virtual portfolio. It should demonstrate your photographic style, should contain powerful, current images and must appeal to the demographic you wish to target.

Preselling. Before my website was up and running, clients called my studio and left a message asking me to call them back with prices for my work. It took a great deal of sales training for me to change the course of that conversation from their first question on price to a focus on their portrait desires and needs. My website changed all of this. When clients get my machine, they hear a message containing my web address—and often hang up. When I listen to my messages, a hang-up is generally followed by a message from an enthusiastic woman, asking if I could create for her and her family images like the ones shown on my website, and telling me that price is not a factor.

▶ **KEEP IT FRESH**
Every time you update your print materials, go back to the same locations and distribute the materials again. You may pick up a client who did not respond to the first postcard or flyer you handed out.

Facing page—Images displaying your unique style not only help draw new business but can distinguish your studio from other photographers' studios.

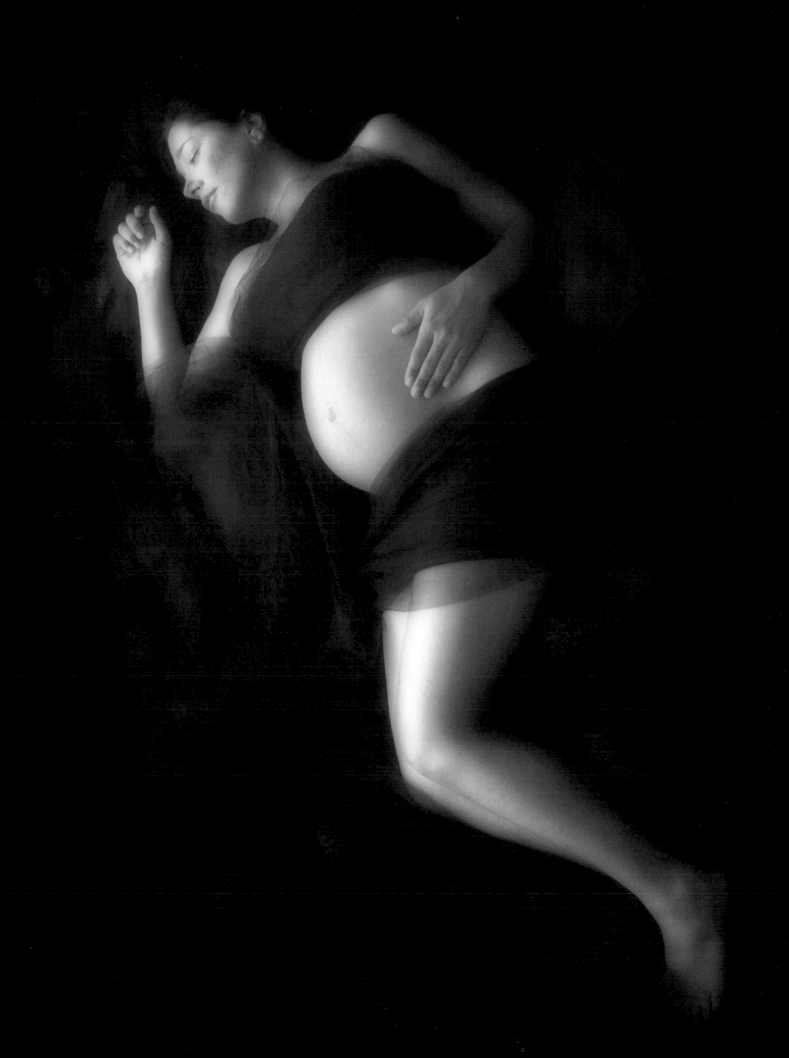

My website is designed to look like an artist's site—it doesn't resemble those used by most family photographers. It immediately creates an impression in the prospective clients' minds that they can work with an artist, not just a photographer who documents a moment. I now book portrait sessions for 100 percent of visitors to my website.

Professional Help. A quality website is a critical component of your marketing strategy. This is not the place to take a do-it-yourself stance. Though hiring a web designer can seem a sizable expense, the rewards are worth it. A custom-designed site can help you to position yourself in the market in terms of portrait style and price and will help you stand apart from your competitors. If hiring a professional designer is cost prohibitive, consider using a

Top—Your website's home page will either inspire your client to use your services or turn them away. The page should portray your signature style and entice the viewer to want to see more images. Once inside your site, your images will inspire the client to book a session. Bottom— Use a strong image on your enter page. This page will help set your studio name, logo, and portrait style firmly in your client's mind. Website by www.bcre8ive.com.

A good website is easy to navigate, with all elements a client may want to investigate clearly labeled. Your images should be the most eye-catching feature of your site, but be sure that your contact information is clearly visible. Also, be sure to provide a direct link to your e-mail address. Website by www.bcre8ive.com.

web design template. Before committing to a given template, though, research your competitors' sites to be sure you won't be using the same design.

Key Elements. No matter who designs your site, you will want to ensure that it features some critical elements.

First, make sure your images are fast-loading. Your potential clients are not going to want to sit for a long time in front of their monitor waiting for your images to load. Featuring a high-impact static image can be enough to lure viewers to enter your site. You can also consider using a loading bar along with a static image; that gives viewers an idea as to how long it will take for remaining images to load.

Choose to showcase only your very best images. Padding the site with extra images will draw attention away from your strongest portraits and can steer viewers away from your site. Less is more, and it will only take clients a few minutes to decide they like your work and want to hire you.

Make sure that the name of the studio, your address, city, and state, and phone number are easy to find and are legible.

Online Proofing. Successful photographers know that selling your images in a face-to-face meeting yields happier clients and bigger sales. After taking the time to develop a rapport with your clients, you owe it to them to create an evocative, emotional presentation in which you can answer questions, explain options, and share in their joy. Post your images online only once you've held an in-studio consultation—and for a limited time only. This creates a sense of urgency and encourages friends and family to place orders, even if they live across the country. Who knows? This option may also help you to win more clients.

You might also consider offering online proofing if your pricing is structured in such a way so that the client has prepaid most of her costs prior to buying the prints (e.g., by paying a higher session fee, prepurchasing an album, etc.).

TELEVISION ADS

Television advertising is cost prohibitive for most photographers. An excellent way to take advantage of the reach of television is to join with other businesses or to partner with a television station to raise money for a nonprofit organization. By taking on this task, you're likely to leave viewers with a favorable impression too.

WORD OF MOUTH

Word-of-mouth advertising is your best ally. A satisfied customer will tell others about their experience, building your client base at no cost to you.

You can offer existing clients a fabulous price break on their pregnancy portrait or a great discount on their next session for referring an expecting friend or family member to your studio.

KEEP THEM COMING BACK FOR MORE

Perhaps the easiest way to generate pregnancy portrait business is to get past clients back into the studio. Make sure that all of your clients are aware of every type of service you offer. Your wedding clients can be great repeat clients when they decide to start a family. A first-time family portrait client may also benefit from some pregnancy portrait information; you never know when her family will grow. Always tell your clients about the array of services you offer. They are your walking billboards.

PORTRAIT DISPLAYS

Because pregnancy photography is such a specialized area of photography, you cannot rely on all of the avenues you might employ to market your services to your general portrait population. One approach that works particularly well is to ask local businesses that cater to your prospective clients if they can devote a little of their wall space to a portrait display.

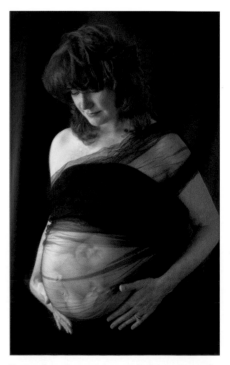

The best places to set up displays are in obstetrics and gynecology offices, fertility clinics, maternity shops, and any other business that caters to babies. Some practitioners and business owners will provide the opportunity without requiring any compensation, as your portraits can add to their decor. Others may want to strike a trade agreement: one of my associates allows me to show my portraits in her office in exchange for a yearly portrait session and framed prints of her three children (you might consider offering gift certificates for free portrait sessions that the business owners can give to loyal clients). This particular display has brought me some of my best clients.

Creating large displays in local shopping centers or malls is another means to marketing your work. You can rent window space from other businesses with the same clientele or can even seek to display you work inside the store.

Do a little research to ensure that you are displaying your work in businesses frequented by your desired demographic. Renting display space can be expensive, so you'll want to do all you can to attract higher-end clients with discretionary income that they are willing to spend on your portraits.

Your unique imagery is a powerful motivator for prospective clients to book your services. Be sure to include some signature pieces in your product displays.

Consider creating gift certificates that offer the bearer a free portrait session. Offer them to local business owners who can present them to their clients, and note how your client base grows. Gift certificates created by Studio2CDesign (www.studio2Cdesign.com).

David McKay of McKay Photography in Sacramento, CA, took the time to seek out a mall that caters to high-income customers. After negotiating with the mall for four years, he was able to create a beautiful display of his images that suited the overall look of the mall environment. "The key [to making your display work for you] is having work that is unique, different, and high end . . . work that is different from everyone else's and stands on its own," David says.

PUBLIC RELATIONS

If you find the terms "marketing" and "public relations" confusing and assume they are one and the same, you owe it to yourself to read up on the

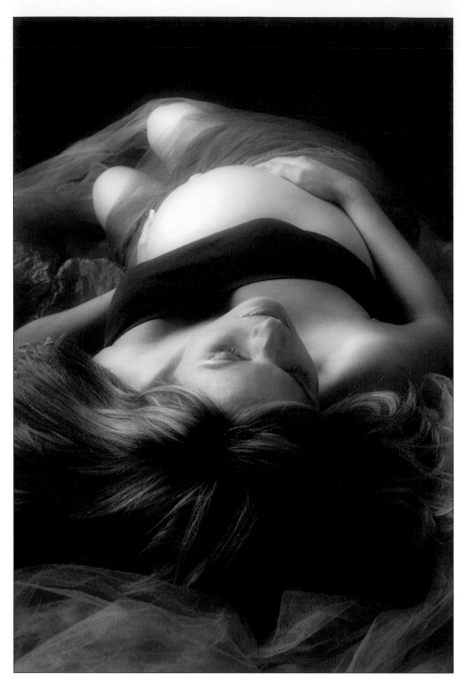

In a market that is saturated with photographers, creating unusual and extraordinary images will set you apart and create an interest in your services.

▶ **GOING THE EXTRA MILE**

When you attend community events, consider donating as a door prize a free pregnancy portrait session and/or a free print. You might also consider giving attendees a discount coupon for a pregnancy portrait session. If they can't use it, they can pass it on to a mother-to-be in their family or social circle.

Contact your local Chamber of Commerce to determine which businesses will allow you to display and distribute your print materials. These folks can also provide you with contacts for organizations that may be looking for speakers and donations from local businesses.

power of maximizing your public relations. Eric Yaverbaum, Robert W. Bly, Ilise Benun, and Richard Kirshenbaum have written an easy-to-read, informative book called *Public Relations for Dummies* (Wiley Publishing, 2006), which you can pick up for under $20.00. You'll enjoy learning about the many ways you can expand your client base.

Networking is a critical component of achieving name recognition. As you will see, the photographers interviewed in chapter 9 have employed many of these age-old techniques. Many of them regularly attend weddings, Chamber of Commerce mixers, special interest clubs, and museum and art gallery openings to mix and mingle—and hand out business cards and walking cards (small cards printed front and back with more information than a business card but less than a brochure).

The importance of networking has been spoken on extensively by many successful businesspeople. Zig Ziglar and John P. Hayes, Ph.D. have authored *Network Marketing for Dummies* (Wiley Publishing, 2001), a great little book that you can pick up for under $22.00. In it, you'll learn a wealth of ideas that will help you amplify your visibility in the community. From attending civic organization meetings, to taking on a speaking engagement for a local organization, to holding your own gallery show or "mother's tea" for young women with small children, to displaying at the local county fair, to writing articles on the beauty of pregnancy portraits for the local parents' newsletter or community newspaper, to being a sponsor on public television's annual auction where a buyer can donate a set amount to the PBS station and have a sitting with you, to giving away a free sitting and an 8x10-inch portrait through raffles conducted by the Chamber of Commerce, Rotary Club, or mothers' clubs—there's no end to the public appearances you can make to reach potential clients. As politicians know, you must meet and mingle, see and be seen in a wide array of community events to gain recognition and win the public's interest.

GENERATING YOUR OWN BUZZ

The parenting and child-oriented newspapers, little neighborhood newspapers (mostly weeklies), and the family sections of local newspapers are always looking for new stories. Consider scheduling a meeting with the editor of one of these publications, and tell them about the growing trend of women having their pregnancies recorded and showcased in family portrait albums. Many editors and reporters will be surprised and pleased to interview you, and when your story appears in print, you will be viewed as the local expert on pregnancy portraiture.

Expressive images not only tell a story, they also make great marketing pieces.

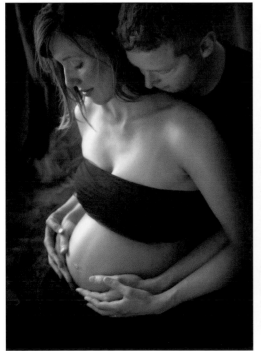
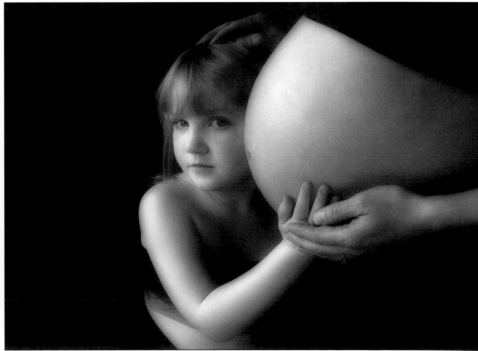

SALES

Many people believe that capturing images is the most important part of their business. Of course, a photographer cannot *stay* in business unless they sell their images!

There are many proofing options available to photographers and their clients today. We've found that projection works best for our studio. Because we cater to higher-end clients, we often have the option to allow our clients to preview their images on their large-screen televisions in their own home theaters. This seems to produce better sales than do in-studio presentation sessions, as we can recommend particular portraits in larger sizes for display in specific areas of the home (with a quality frame, of course) or particular specialty products.

We first run through a slide show of the images, set to royalty-free music, to really create an emotional response from the viewer. Then the images are presented one by one or in small groups so the client can select her favorites and place her order. We also recommend several add-on items, including frames, albums, and image boxes, jewelry, and purses. (*Note:* If you must, you can send the DVD home with your clients to give them some time to think about their order. However, this can discourage sales. If you do send the DVD home, get a large, nonrefundable deposit, and tell the client that the amount will be applied toward the price of their product order when they come into the studio to place their order.)

You can also add the DVD slide show to your product line (again, you must be sure to use royalty-free music) and offer it for sale, or offer it as a gift with purchase if your client's order reaches a specific dollar amount.

Projecting your images assures the biggest possible sales. Putting the images to music and showing them large creates and emotional appeal for your clients. Kim Treffinger's presentation room (below) is decorated with samples of her work, and products are displayed for clients to see and touch. The rich colors used in the room create help to create a luxurious, affluent feel. Presentation room photo courstesy of Kim Treffinger, www.treffingerstudio.com.

10. PROFESSIONAL PERSPECTIVES

I n this chapter, we'll take a look at some of the ways portrait photographers at the top of their field approach pregnancy portraiture. You'll find that many of the photographers profiled here have similar viewpoints; however, you'll also gain an appreciation for the innovative approaches each photographer uses to personalize their work and set their business apart from the competition.

KEVIN KUBOTA

Background. Kevin Kubota of Kubota PhotoDesign, Inc., located in Bend, OR, is a wedding and portrait photographer who creates images that speak to the heart. They are filled with emotion, joy, intimacy, and impact. Who better to capture the joyful, intimate moments of pregnancy?

Photo by Parker Pfister.

Kevin's photos have been featured on the covers and pages of many popular magazines and photography books. He has been a Nikon-sponsored speaker, and his work with the Nikon digital camera has been the focus of the company's advertisements. He is named in the Legends section of the Nikon website (www.nikonnet.com) as a prominent wedding photographer. Kevin is also a PPA Photographic Craftsman.

Kevin loves to share his Photoshop tricks and actions, and his trademark Digital Photography Bootcamp™ seminars consistently sell out nationwide. He is the author of *Digital Photography Boot Camp* (2006), published by Amherst Media. He is also the creator of a number of Photoshop actions that will allow you to add beautiful portrait effects quickly and easily. For more information, go to www.KubotaImageTools.com.

Personal Satisfaction. For Kevin, the personal rewards that come from creating pregnancy portraits are many. He loves providing the subject with a once-in-a-lifetime image that she will cherish and hopefully pass on to the little one inside her belly. He also gets a lot of satisfaction from being able to photograph a woman who may feel a little large and unattractive, because when they create a beautiful portrait, she's so proud and excited. "I had one client whose mother simply could not understand why she wanted pregnancy portraits made and tried to talk her out of it. After her mom saw the images, she loved them so much she bought many portraits herself," Kevin says.

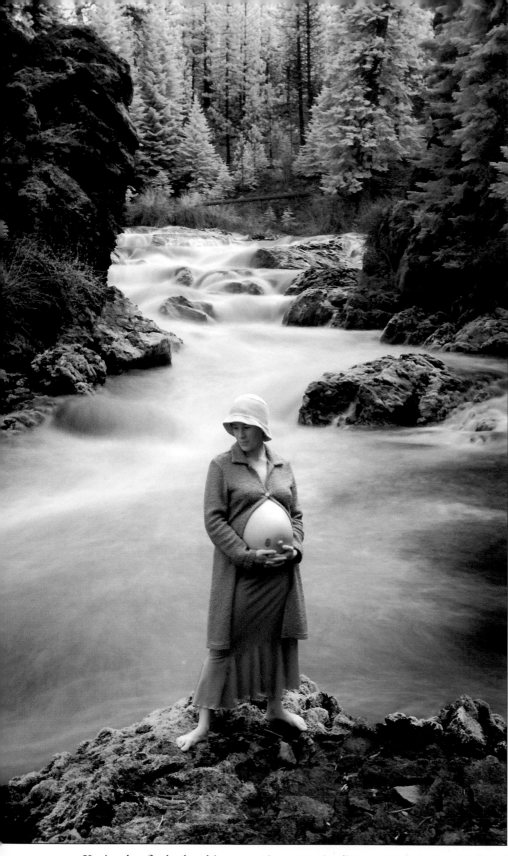

For this image, Kevin's subject hiked down a rocky trail, through freezing water, over logs, and out onto a slippery riverbed to get to this spot (it was the client's idea)—something Kevin wouldn't ask a pregnant woman to do unless she was completely comfortable with it. Kevin used a tripod-mounted Nikon D1x, fitted with an infrared filter and set to the black & white mode. The image was made under an overcast sky, and the exposure was 4 seconds at f/8. Photo by Kevin Kubota.

Kevin also finds that his maternity portrait clients are always excited and eager to do whatever it takes—which always amazes him considering their condition and the fact that moving and holding positions can often be uncomfortable. He appreciates when they are willing to go outside with him and find a great spot to make the images. For one session, Kevin's pregnant sub-

ject hiked down a rocky trail, through freezing water, over logs, and out onto a slippery riverbed to reach an ideal spot (it was her idea). Kevin notes that this is something he wouldn't ask the subject to do unless she was completely comfortable with the idea. He also says, "I think there is something about pregnancy that makes women bolder than usual—or maybe I'm imagining things."

Kevin says that in adding pregnancy photography to his repertoire, he has found a niche he really loves. In fact, he has come to enjoy pregnancy photography and wedding photography the most. He adds that although pregnancy photography, in and of itself, isn't a big contributor to his financial success, it's personally rewarding and gives him a chance to create more artistic images and display them in his studio. This inevitably draws clients to book his services for their other portrait needs as well. He feels that this is the time in a woman's life when she is most beautiful. "It's truly an amazing and rewarding thing to be able to capture," Kevin says.

Professional Tips. Kevin finds that the timing aspect of working with this client demographic can be difficult. Occasionally, there are days when the moms just don't feel good and the session must be rescheduled. Also, the window of opportunity is relatively small to begin with. Kevin likes to photograph them just after the eighth month, when they are large enough to really look pregnant but are still somewhat mobile.

In the studio, Kevin often prefers to capture black & white portraits, since the backgrounds are very simple and the image is all about the form of the body. Also, black & white photos can be a little more forgiving: he once photographed a woman pregnant with twins, and her belly was so large that it was literally purple from stretching. This, he decided, was definitely a black & white shot! When shooting outdoors, Kevin's preference is typically to shoot in color.

What techniques and technical advice does Kevin share? "I love my Nikon 85mm f/1.4 lens. I also use my 70–200mm f/2.8 lens when I need to get farther away—like across a river! I think the shape of the body is more pleasingly represented with an 85mm or longer lens (with his Nikon, there's a 1.5x lens magnification)."

Marketing. Kevin notes that booking a couple's wedding photography and creating great wedding portraits can easily lead to pregnancy, baby, and family sessions down the line. When he first considered branching into maternity portraiture, he simply sought to photograph pregnant women who had that special glow. "Some pregnant women feel beautiful and radiant when pregnant; others don't feel very attractive at all," Kevin says. "I can usually tell right away. I would just ask them (or my wife would, if possible, as it's less awkward for them) if they'd like to do some photos for my portfolio," he adds. Simply initiating this contact and creating beautiful images for these women resulted in word-of-mouth marketing and a growing client base.

TERRI LEE

Background. Terri owns and operates Starlight Photography in Mission Viejo, CA. A photographic instructor, Terri has also been awarded a fellowship from the Professional Photographers of California in recognition of her service to the photographic industry. In 2004, Terri conducted a program at the Professional Photographers of California's Western States Convention called "A New Life: Maternity and Newborn Photography." In 2005, she was named PPA's Photographer of the Year and was awarded her Photographic Craftsman degree from the same organization.

When Terri first began her work as a professional photographer, she concentrated on wedding photography.

Many of her happy bridal clients became maternity portrait clients. As her skill level and portfolio began to grow, Terri's satisfied pregnancy portrait clients referred their pregnant family members and friends.

Other referrals have come obstetricians' and other physician's offices. Terri provides local doctors with portraits that enhance their waiting rooms' and examination rooms' decor in exchange for placing her marketing pieces in the waiting rooms. The practice has provided mixed results, but it seems to work best in offices that serve a predominance of her target market. Terri's business is low volume by choice, but she is always pleased when her targeted

Above—Photo by Mike Lee. **Below**—Terri used shadows almost more than highlights to show the sensuous form of this pregnant woman. Fabrics are her favorite device, as they allow her to draw attention to certain areas and hide others. Photo by Terri Lee.

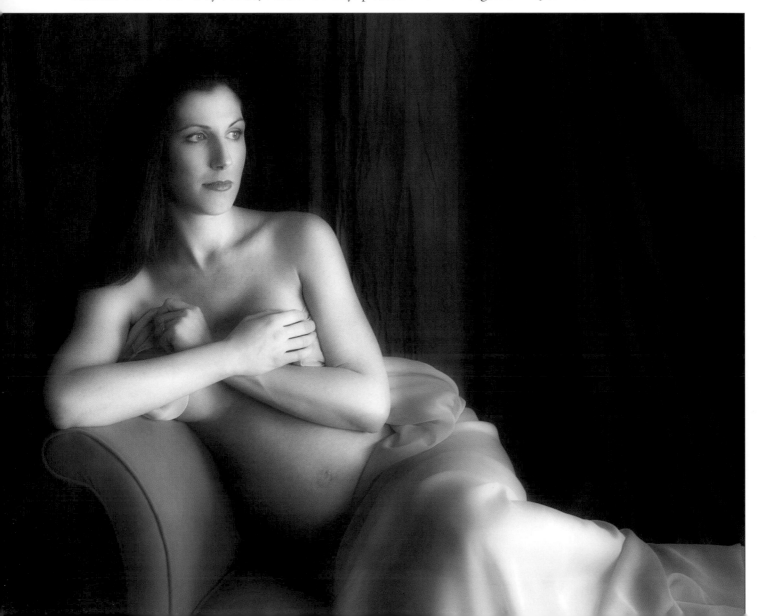

marketing brings her the kind of client who will adore and appreciate what she has created for them.

Personal Satisfaction. It is of the utmost importance to Terri that her clientele approach their photography session with high expectations and confidence. Her studio provides a safe, calm, and nurturing environment in which to collaborate and create one-of-a-kind imagery.

For Terri, the honest emotional response from the client, not only to her portraits but to the process of recording the images, is the greatest reward pregnancy portraiture presents.

Terri says she likes clients who are adventurous, as they bring out the best in her as an artist. If she perceives a client to be comfortable and open minded, she will spend time doing unique lighting setups and poses. This stretches the boundaries of her imagination and makes her feel more creative. Terri dislikes photographing anyone who is uncomfortable, despite her efforts to relieve their tension. "When a subject is, for whatever reason, self-conscious or untrusting of me, I pick up on it and it seems to repress my creativity," Terri says. "This hasn't happened very often, thankfully," she adds.

Terri feels there is an intimate circle of communication that extends from the parents, to the child, to Terri during each session. "I always feel privileged to be present at the moment when love is so thick in the air that we can all feel it at the same time. That is what motivates me to find that person who needs me to tell their story," she says.

Professional Tips. Terri creates sensitive, emotional portrayals of expectant parents and their newborns. Using available light or studio lighting allows her to beautifully capture the sensuous form of the pregnant woman—as well as the translucent, delicate skin of the newborn at a later session.

When in the studio, Terri keeps her light source as close to the subject as possible to produce soft light. Her lighting style will change often, even during the course of a single session. She thinks of her lights as a painter would, using highlight and shadow to sculpt every subject. She asks, "Why would I ever want them nailed down?" Terri hopes that every session will contain something new and different, for that client alone. "Just because you master one style of lighting doesn't mean you are married to it," Terri advises. Experimenting helps Terri to keep her creativity alive.

Like many photographers, Terri likes to use a long lens when possible, especially when shooting outdoors.

Terri has an extensive background in the arts; she spent fifteen years as a retouching artist before becoming a photographer. With digital imaging, she can easily retouch her images and can provide a wide variety of photographic styles and finishes for her client. Terri likes some images in black & white, or sepia, or cyan; she's never quite sure how an original image will look until she's played with her creative options postcapture. "I don't prefer one look over another except as the image demands," she says.

Marketing. Terri finds marketing her own work difficult and prefers the idea of outsourcing her marketing as she believes someone else could toot her

▶ **PROFESSIONAL REFLECTION**
"I always feel privileged to be present at the moment when love is so thick in the air that we can all feel it at the same time."
—Terri Lee

horn better than she can. She feels that maternity photography is an unfamiliar and often scary idea for many prospective clients and that marketing the concept works best when the sessions and images are described and explained, with sample images being shown. This approach works especially well when coupled with an enthusiastic endorsement from another client.

Because of the visual nature of the photography business, Terri feels it is important to produce high-quality, colorful, eye-catching marketing pieces. Her own materials can be found in the waiting rooms of local pediatricians' and obstetricians' offices and can be easily slipped into a purse while a client is waiting for an appointment. Clients leaving her studio also take her marketing pieces and share them with friends and family. Word-of-mouth advertising is one of the most effective ways to expand the client base.

On occasion Terri attends community and charity events to meet potential clients. She also donates services and auction items to charitable groups whose members fall into her preferred demographic. Additionally, she recommends speaking to interested groups, where your wonderful images can be shown and questions can be answered in a group setting.

Without the marketing she has done, Terri feels that she would not be able to create the work she is most passionate about—maternity and newborn portraiture.

TIM MEYER

Background. Tim Meyer has worked as a full-time professional photographer since 1979 and currently serves as the chairman of the portrait division at the Brooks Institute of Photography in Santa Barbara, CA. He has achieved the prestigious Master of Photography, Photographic Craftsman, and Certified Professional Photographer distinctions from PPA and also holds a Master's of Art degree from California State University—Fullerton. He has had numerous one-man exhibitions of his fine-art portraiture around the country.

Tim finds pregnancy portraiture satisfying and says, "Men have always considered a pregnant woman beautiful. It is perhaps tied to our natural feelings as fathers and our love for the woman with whom we share the experience. It is exciting to see how maternity portraiture has become such a large part of the portrait marketplace and how it is appreciated by men and women alike."

Working with Clients. Tim finds it is more difficult for male photographers to photograph women in what approaches a "figure study" style of imagery. He always works with a female assistant in the studio. Not only does that put the women at ease, but it allows his female assistant to help them with clothing adjustments. Tim notes that it is important to consult with the client before each session to determine what style of portrait they would like and what level of modesty is appropriate for them. Not doing so before a session can create an awkward situation, he warns.

Tim observes that creating pregnancy portraits is very rewarding both to the photographer and the subject. He feels there is a joy in seeing clients ex-

Photo by Dea Bachand.

This portrait is a contemporary take on a lighting style popularly used in the 1930s. The use of two edge lights complements the pregnant form, and a spotlight highlights the face. Photo by Tim Meyer.

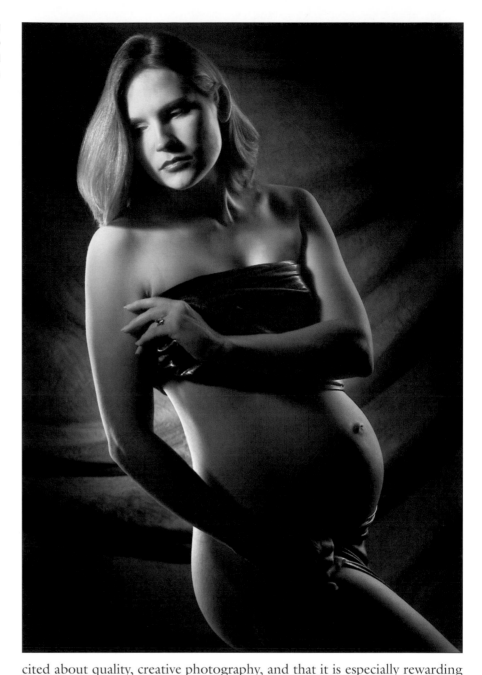

cited about quality, creative photography, and that it is especially rewarding because pregnancy portraiture is new to many clients. Tim says his clients have told him wonderful stories about sharing their images with friends and family and the amazing and joyful responses they have elicited.

Technical Tips. Tim feels that a 60–80mm lens is a great choice for full-frame digital SLRs and says that any lens that is about 1.5 times longer than a "normal" lens for a 35mm-type camera would work well.

When lighting their pregnancy portrait subjects, most photographers prefer large light sources—usually a window or a large softbox. This type of light tends to be very forgiving and also renders the shape of the body beautifully when it is properly used. Tim often uses soft light too but sometimes lights mainly for the face, employing some of the more dramatic studio lighting techniques to add impact to the portrait.

Marketing. Much of Tim's client base has been built up through word-of-mouth referrals from previous clients. Developing marketing relationships with pediatricians and maternity or "mommy and me" groups has also worked well for Tim, but he warns that you need to choose a group that serves your target demographic. Maternity portraiture has changed and grown dramatically over the past few years, Tim observes. Whole new generations of women, older women, are having children. They are looking for new ways to capture the emotions of that experience, and pregnancy portraits fill that need.

GAIL PATRICE

Background. Gail Patrice of Patrice Photography of Gold River has been a Sacramento, CA, area photographer for more than twenty-five years. Gail trained formally at the West Coast Photography School, the Golden Gate Photography School, and California Photographic Workshops. She later served on the board of both the Golden Gate Photography School and California Photographic Workshops. Through her work with other studios in her early years, Gail gained a background in portraiture, wedding, and commercial photography.

Photo by Eleakis Photography (Roger Ele).

Personal Satisfaction. The growth of Gail's pregnancy photography specialty has been gradual. At this time, maternity portraiture accounts for about 10 percent of her client base. Most of her first-time maternity clients are women whose weddings or families Gail photographed in the past.

Gail finds photographing pregnant women very rewarding. She loves the challenge of creating a unique image and capturing a beautiful, historic moment of a woman during this nurturing and loving stage of her life—whether it's their first baby or fourth! Every session is different and memorable: one mom came to the session in labor with her fourth pregnancy, and Gail wondered if she was going to become a midwife!

Gail also enjoys creating couple images that feature the woman's rounded form. "One really big advantage of being a female photographer is that I am comfortable with nude or seminude subjects and have my own wonderful memories of being pregnant," she says.

Gail notes that there is so much attention given to the mom-to-be that the dads sometimes feel left out. "I want them to know how special they are too," she adds.

Technical Tips. Gail uses only northern natural light for her maternity portraits, which streams in through the windows of her warehouse-district studio. (Unfortunately, there is sometimes a lack of privacy—not to mention the distraction of loud machines and men walking by the studio!) Gail uses white or silver panels to provide fill. She prefers simple backdrops and finds that skin tones look rich with black backgrounds. She is constantly on the lookout for rich, soft fabrics to wrap seminude pregnant subjects in.

Gail shoots with a Canon 20D and tends to use an ISO setting of 100 or 200 to avoid grain. She began her career using medium-format cameras and

Gail loves to show skin tones in her images and uses simple fabrics to wrap both mothers and couples in. This image was captured with her Canon D20 at an ISO of 400, a shutter speed of 1/80, and an f/6.1 aperture. The background was commercial carpeting. Available light and a gold reflector illuminated the scene. Photo by Gail Patrice.

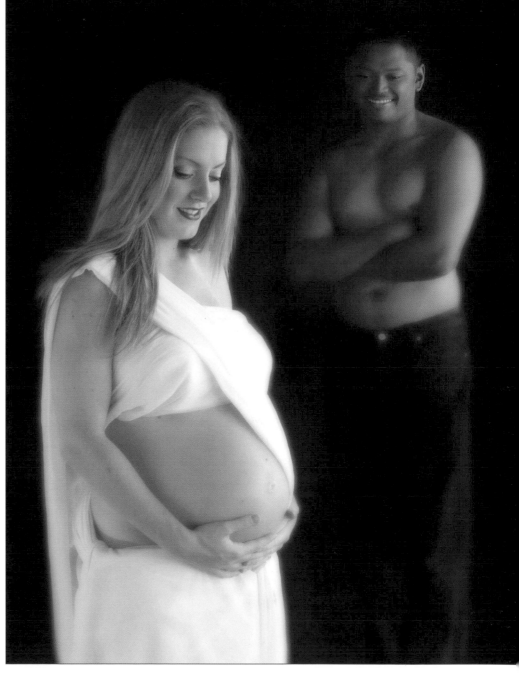

▶ **PROFESSIONAL REFLECTION**

"One really big advantage of being a female photographer is that I am comfortable with nude or seminude subjects and have my own wonderful memories of being pregnant."

—Gail Patrice

fixed lenses, and she now really enjoys the flexibility that using a digital SLR with a zoom lens affords.

She reports that attending photography conventions, staying active in her local PPA affiliate, Professional Photographers of Sacramento Valley, and serving as a past president of that group has helped her to make critical connections and continue her education in the field. She enjoys getting small groups of photographers together for informal workshops, "just to fuel the passion."

Marketing. Gail finds that her best marketing for pregnancy portraiture is word of mouth. The majority of her clients are new moms, so they tell friends, sisters, etc., about their happy experience with Gail in posing for a pregnancy photo. Gail says her clients market her!

KIM TREFFINGER

Background. Kim Treffinger of Treffinger Studio is an award-winning, formally trained fine artist who lives in San Diego, CA. She is widely recognized for her digital painting techniques and has long been known for her success, passion, and enthusiasm across a range of artistic mediums. She was recently featured on Home and Garden TV's *Crafters Coast to Coast* and has shown her work in Southern California and nationally. Kim is a member of PPA, a member of and secretary for Professional Photographers of San Diego County, and a member of the San Diego Watercolor Society and San Dieguito Art Guild. She holds a bachelor's degree in design from the University of California—Davis.

Personal Satisfaction. "I love a client who will put their trust in you to be creative and still have their interest at heart in pushing the limits and trying something new. I love when we are having a great time together and you just know from each successive shot that you are getting something special for the client that they are going to love for the rest of their life," she says.

Sometimes a client arrives feeling critical about their appearance, and Kim is able to break through and reassure them that they are going to get some great images they will love. It is those clients who seem to appreciate the session—and the portraits Kim creates—the most. She enjoys the creative process of working on an image and artistically taking it to a whole new level.

Photo by Barbara Steinberg.

Kim loves working with soft, natural light. This image was captured on the sofa in her client's home. Photo by Kim Treffinger.

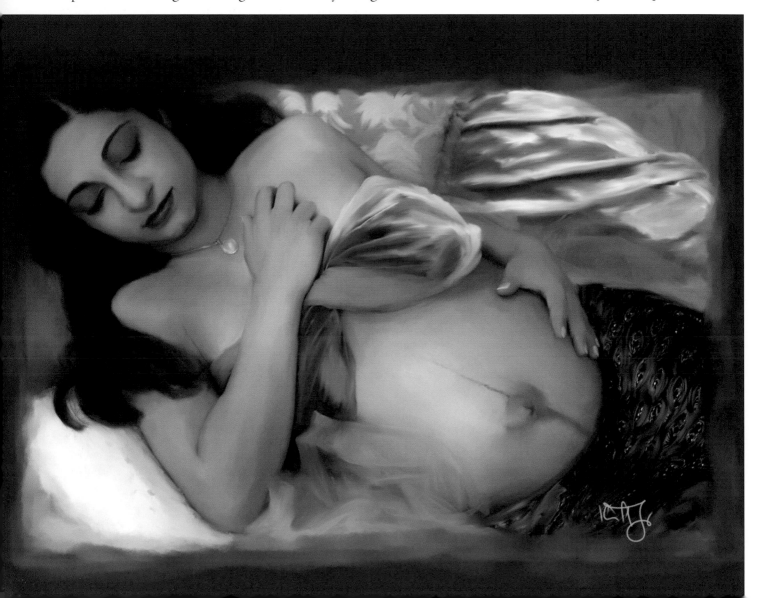

Kim loves her job more than anything (aside from her children). "I was a traditional painter for many years before discovering that I could combine my painting skill with portrait photography," Kim says. "There is nothing like the personal connection you get with your client when you know you've created something really special that they never expected. Seeing their tears of joy when they see the images for the first time is priceless," Kim says.

Marketing. So far Kim has been very lucky with word-of-mouth referrals, but she is beginning to provide other professionals with gift certificates they can offer to their clients as thank-you gifts to build her client base.

Her specialty is digital painting, and in her area there aren't too many photographers with a fine-art painting background, so it really sets her work apart and has allowed her business to grow relatively quickly.

Kim's clients really enjoy her coffee-table books produced using fine-art images from a single session or multiple sessions. She finds that once a client sees a book she has created for another mom, they become excited about creating their own book, too.

Technical Tips. Kim shoots with a Canon 5D and tends to stick to her 24–70mm f/2.8 lens. She prefers to use natural light whenever possible. She has several Larson standalone reflectors in matte silver and shiny silver that are used for fill.

Kim produces portraits in a variety of presentations, depending on the subject: she says black & white is a great choice that really pulls the portrait together when there are too many distracting colors or textures in the composition. Combination black & white and color portraits are a popular choice, and her clients also enjoy her color images warmed up with a bit of a sepia tone.

As mentioned, Kim also creates painted portraits. She finds that it's best to boost the color saturation of images she plans to paint to ensure the most authentic results.

CARL CAYLOR

Background. Carl Caylor grew up in Wisconsin and currently lives in Upper Michigan. His studio, Photo Images by Carl, is located in Iron Mountain, MN. He has been involved in photography for more than twenty years. He started his career in the darkroom as a custom printer and technician, a fact that has proven to be a great asset to his photographic and teaching career. Carl has earned the designations of Master Photographer and Photographic Craftsman from PPA. He has numerous Loan Collection images and has received several Kodak Galley and Fuji Masterpiece Awards. Carl has twice been named Photographer of the Year by the Professional Photographers of Wisconsin. He teaches seminars from coast to coast.

Personal Satisfaction. What Carl appreciates about having added pregnancy photography to his repertoire is that it has created repeat business. "It makes me part of a client's family experiences and allows me to watch the guests' children grow," Carl says. He feels that the most rewarding aspect of

Photo by Teri Shevy.

pregnancy portraiture is the creative challenge of doing something unique and artistic during a tender moment in a young family's life. "We already have a tender emotion presented to us, but we need to personalize and immortalize it for the couple," Carl explains.

He shares, however, that some new clients' husbands feel uncomfortable with the close, sometimes very personal nature of the session and images and

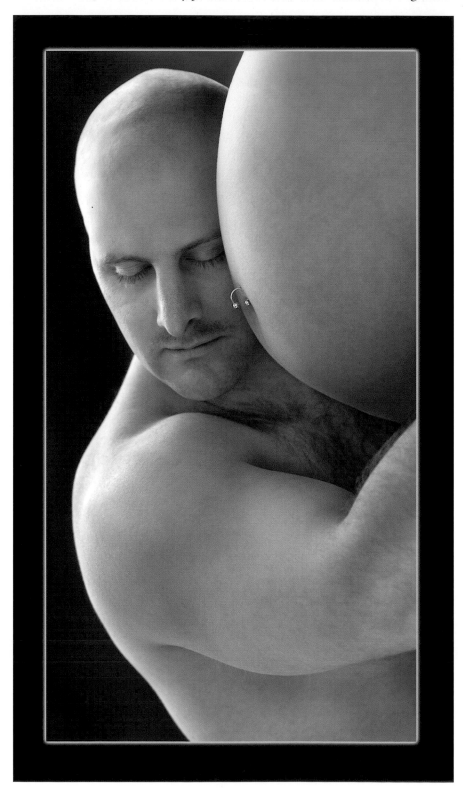

Carl created this exquisitely lit image to show the relationship between the father and his unborn child. Never underestimate the power of emotional undertones. Photo by Carl Caylor.

feels it would be easier for the men if he were a female photographer. The mothers-to-be love the experience, though, says Carl, so he tries to include Dad as much as possible.

Technical Tips. "If beauty were only skin deep, every photograph would reveal the same personality," says Carl. He feels the goal of creating a portrait should be to produce an artistic expression that goes past the outer layer, beyond the first impression, and defines the subject's essence. Artistry is a large component in this undertaking; Carl's philosophy is that photography is art and family history both. He feels that, without an artistic sense, a portrait has no longevity and will not be part of one's family history.

Carl recommends using a longer focal-length lens, as it allows you to give the client a little more personal space. Also, the longer lens allows for less foreshortening of body parts, more realistically capturing the shape and form of the mother.

Carl finds that window light is the most flattering and comfortable lighting option for his subjects. Since a subject's emotions are generally on the tender or soft side, he portrays the woman with the mask of her face in shadow. "Psychologically, people are deeper in thought when they are not brightly lit. Therefore, we want to make sure that the lighting style matches the emotions we want to portray," Carl adds.

The final presentation of the image depends on the mood that Carl and the subject want to create. If the client is dark-haired and wearing earth tones, for example, Carl will often create a black & white image; if the colors and the subject's hair are lighter in tone, the final image may be a watercolor.

Marketing. Carl says his best marketing tool is word of mouth but that a display of images at local obstetrics and gynecology offices and displaying pregnancy portraits in his gallery also attracts a number of new clients.

Carl notes that as a pregnancy photographer, you are creating the first images of a new generation, and as those babies grow, you can create their children's portraits, family portraits, senior portraits, weddings, etc. He says, "It can't help but grow your business."

GIGI CLARK

Background. With four college degrees, Gigi has a varied background including multimedia, instructional design, graphic design, and conceptual art. She brings all of her multi-disciplined talents to her upscale wedding and creative portrait photography business, Rituals by Design, located in Southern California.

Gigi has received numerous awards and honors, including several First Place Awards in PPA and WPPI competitions and the first-ever FujiFilm Setting New Trends Award. In addition, she has recently won the highly coveted Kodak Award of Distinction. Her work and writings also appear in numerous journals, magazines, and books. She has also earned PPA's Master Photographer, Photographic Craftsman, Certified Professional Photographer, and Approved Photographic Instructor designations.

Photo by John Clark.

Gigi specializes in black & white photography. The fine-art quality of her images goes far beyond mere documentation. She is highly respected by other photographers who appreciate her style and sensitivity. Legendary portrait photographer Monte Zucker once said, "Then there's Gigi Clark, who's stopped everyone cold in their tracks. Her images are more creative than one could imagine. With no 'rules' to keep her down, she consistently comes up with great photographs!" (*Shutterbug*, January 2000). That review is certainly well deserved.

Personal Satisfaction. "To say pregnancy portraits changed me for the better is an understatement," Gigi shares. She sees capturing pregnancy images as the new frontier in portrait photography and finds it exciting that all of the options haven't been explored yet. Because of his "uncharted territory," she is constantly challenged as an artist, and she lives for the ongoing artistic challenge.

Gigi loves the challenge, however. She notes that because of the nature of the mother's condition, there will be cancellations and a need to reschedule appointments, and you will need to be patient and accommodating of your clients. Gigi has even scheduled sessions late in the game when a pregnant mommy was due to deliver in less than two weeks!

This portrait, entitled, *In the Manner of Gauguin, Unfinished Work*, was inspired by Gauguin's memorable painting, *Nevermore,* a portrayal of this thirteen-year-old mistress shortly after the birth of their child. Gigi was captivated by the lyrical, colorful, and symbolic meanings found in the painting. In her version, she also took into consideration the personality of the pregnant mom and focused on her love of the sea and related elements. Her final presentation is three dimensional, with the image "floating" on top of the frieze layer, much as you would when floating in the sea. Gigi believes that an image should explore and illustrate the psychological depths of the subject. Photo by Gigi Clark.

Gigi is willing to give up some private time to take care of her expectant clients and work with them on odd schedules. Her reasoning is practical: "It's *not* all about business at hand, but future work that follows, especially after the baby is born," she says. The key to her success is to preplan the session, allowing some extra time (unbeknownst to the mother until the session time) to take away any stress of being "on the clock." "'Work hard, give extra time; the business will follow,' has always been my philosophy," states Gigi.

Gigi uses "quick-sets," that is, short bursts of intense shooting with frequent breaks for the new moms, as you only have a short time before the weight of baby's body on the mother's organs begins to make the subject uncomfortable. Gigi also recommends having a restroom nearby and a cooler or mini fridge filled with chilled juices to give mom energy when things starts to flag. Juice is sugar water to the body and boosts the electrolyte levels quickly, giving the tired mom-to-be a quick energy boost. It is simply good business to provide customer service—costs are minimal, and the returns are worth it.

Gigi also finds it rewarding to be able to document the "life cycle" of a family and solicit their involvement in conceptualizing meaningful, highly artistic portraits. For example, she photographed a client's wedding, then created the ultimate portrait of the client's late pregnancy with her twins, and finally continued the series with portraits of the woman and her husband holding each twin. The images, which were painted and gilded in the manner of Art Deco painter Gustav Klimt, were featured in a triptych entitled *Ode to Joy*.

Gigi doesn't find any part of creating pregnancy portraits difficult. From customer courtesies, to posing comfortably, to planning flexible schedules and expressing unique artistic approaches, "it's magic beyond words" to Gigi.

Technical Tips. Gigi prefers to use portrait length lenses (150mm for Hasselblad work and 105mm for 35mm work) to separate her subjects from the background. She also feels that using such a focal length caresses the subject's face, making her features look great. Many of her lighting setups consist of an oversized softbox (or softboxes) and reflectors.

Gigi feels it's important to design a portrait *with* her clients, tying in external elements that can tell you more about them to create a portrait with an enduring quality that will be cherished beyond the subject's lifetime. Her decision to create a black & white or color image depends on her objective for the portrait. "Black & white clarifies the viewers' impression of the portrait and focuses the eyes on the compositional elements of the image. Color, on the other hand, dazzles the eye but allows for emotional symbolism to be found in portraiture," she says. For example, Gigi created a portrait called *Heart and Soul: The Story of Eros and Psyche* for a couple's tenth wedding anniversary. Considering that since the Roman times, the color orange has symbolized passion and a butterfly has symbolized the soul, she employed these symbols and much more to create a portrait that tells the story of who they really are and what they do for each other.

▶ **PROFESSIONAL REFLECTION**

"To say pregnancy portraits changed me for the better is an understatement."
—Gigi Clark

Marketing. Gigi discovered that a great way to reach mothers-to-be is to network with "parallel" markets (i.e., stores where pregnant moms shop, OB-GYN offices, etc.). She often displays "mini art shows" in obstetricians' and gynecologists' offices that are visually rewarding for both the doctor and the patients. A discretely placed information "pocket" is also included with the display. The fine-art quality of her portraits lends them to be displayed in the doctors' permanent collection, and the works speak for themselves over time. This type of marketing reaches the public in a way that is better suited to the visual nature of our art than are bulk mailings, print ads, and in-studio displays. "The key is to restrain yourself to show only a few, highly specialized pieces, to gain the attention of potential clients," Gigi says.

KATHLEEN AND JEFF HAWKINS

Photo by Jeff Hawkins.

Kathleen Hawkins and her husband and partner Jeff Hawkins operate Jeff Hawkins Photography, a successful, fully digital high-end wedding and portrait photography studio in Longwood, FL. Kathleen holds her Photographic Craftsman degree and earned a masters in business administration. She previously taught business courses for a Florida university. She has also served as president of the Wedding Professionals of Central Florida.

Kathleen and Jeff are coauthors of *Professional Marketing & Selling Techniques for Digital Wedding Photographers* (2nd ed.; 2006) and *Professional Techniques for Digital Wedding Photography* (2nd ed., 2004), both published by Amherst Media. Kathleen is the author of *The Bride's Guide to Wedding Photography* (2003), *Marketing & Selling Techniques for Digital Portrait Photography* (2005), and *Digital Photography for Children's and Family Portraiture* (2nd ed., 2008), all from Amherst Media. Kathleen and Jeff are both very active in the photography speaking circuit and take pride in their impact in the industry and in the community.

Personal Satisfaction. To Kathleen, pregnancy is beautiful, and capturing that moment in time is priceless. She says many clients feel self-conscious about their swollen ankles and stretch marks, and that seeing the joyful expression on their faces when they realize how Kathleen and Jeff have captured their inner and outer beauty and their joy about their pregnancy is the most satisfying aspect of pregnancy photography. "It is more rewarding than words can express," states Kathleen.

Technical Tips. Kathleen and Jeff always work with an assistant or make certain someone else (husband or family member) is present during a maternity session. They feel that maternity sessions are intimate, and you should never photograph the client alone.

Like many of the other photographers profiled, Kathleen and Jeff also use a large softbox—the Larson 4x6 Soffbox—for their studio maternity sessions. They favor using a 70–200L f/2.8 lens or the 85L f/1.2 lens set at f/8 with their Canon 5D.

Kathleen and Jeff use sheer fabrics from www.coleandcompany.com to wrap around the mom-to-be and create an elegant, soft background. They

This image, entitled *Belly Basics,* is a simple classic maternity portrait, where you focus in on the side view of the belly. To capture this image, Jeff and Kathleen created a silhouette, lighting the subject from the side with a kicker light placed behind her.

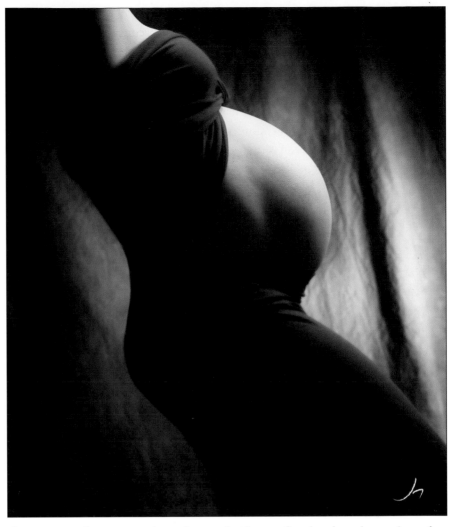

also suggest that you analyze the mother's comfort level to determine what poses you will be able to do, and try creating a series of signature poses to brand your portrait style and look.

Marketing. Kathleen's marketing efforts began with the implementation of her Lifetime Portrait Program. The program permits their wedding clients (who receive a complimentary membership) and portrait clients (to whom membership is available with a purchase) to receive complimentary portrait sessions for their lifetime. Dates, times, and locations are subject to availability and are determined at Kathleen and Jeff's discretion. These sessions typically begin with an engagement session, then move to a wedding shoot. A maternity session is often scheduled some time later.

Kathleen and Jeff promote their lifetime client concept by showing maternity images, newborn portraits, a wedding portraits, and family portraits in displays presented in their community.

Kathleen and Jeff also use Marathon Press's Marketing Partnership Program for direct mail targeted at parents-to-be within a specific income range living within specific zip codes. With the help of their customer loyalty program, their portrait client base increased by 28 percent in 2006, and 78 percent of their wedding clients booked a maternity session.

JUDY HOST

Background. Judy Host, owner of Judy Host Photography, located in Danville, CA (thirty miles east of San Francisco), is one of Northern California's leading portrait photographers. She has earned her Masters and Photographic Craftsman degrees from PPA, and her images are included in the association's national exhibits. Judy has received three Kodak Gallery Awards (1999, 2000, and 2002) in recognition of her creativity and the pursuit of excellence in quality. Many of her images have been exhibited at Epcot Center and are part of a traveling loan collection.

In January 2004 and 2005, Judy was selected by the Hollywood Foreign Press to include a portrait session gift certificate in the presenter gift box for the Golden Globes. She has photographed Jack Nicholson, Pierce Brosnan, Nicole Kidman, Mehki Phifer, William H. Macy, Felicity Huffman, and many other celebrities and is currently working on a journal for *In Style* on the events leading up to the Golden Globes.

In January 2005, Judy traveled to Africa to photograph the presidents of Uganda and Rwanda and several orphanages in both countries. She also traveled to Sri Lanka, India, and Thailand to document the progress of Tsunami

Above—Photo by Amy Cantrell. **Below**—This image was captured with a LensBaby, pointed directly into the window of the studio. The subject's very pregnant body was covered with a beautiful green scarf with a fan blowing in her direction to keep it from falling off. Photo by Judy Host.

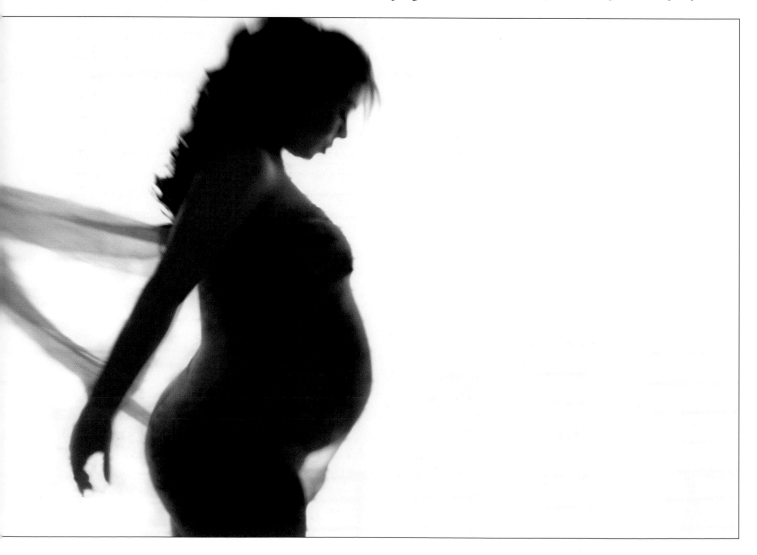

survivors. Currently, Judy is working with the Foundation for Healing Among Nations on a project called Our Soulful Nation.

Judy spoke in Chicago in February 2007 for Pro Labs and also led a series of workshops on lighting and creating your own style for Brooks Institute in 2007.

Personal Satisfaction. "I love what I do," Judy shares. "I find running a business difficult when all I really want to do is create art." Judy says that everyday when she wakes up, she is grateful to make a living doing what she loves to do!

Judy loves photographing pregnant women for many reasons. She feels that creating a portrait that emphasizes this time in a woman's life is an honor. "There is a glow about a woman who is pregnant," states Judy. She also notes, "It's the start of a cycle of a relationship that you can't put a price on. I tend to forget the importance of my place in my clients' world. We are documenting the most precious times of their lives. I'm fortunate to do what I love for a living."

Technical Tips. Judy feels that there is no single focal length, lighting style, or presentation that works for every session. She feels that the best artistic approach (e.g., color or black & white, soft or dramatic lighting, focal length, etc.) for each subject or group is really just a matter of interpretation.

Marketing. Looking for a novel marketing strategy, Judy designed a baby program for her clientele. The program included three portrait sessions; there was no expiration date, and the sessions could be used anytime and anywhere the client wished. The program offered three sessions for the price of one; this advantage made it easy for Judy to sell the program to her clients.

To get the word out about the program, Judy used a listing service to obtain addresses of new moms living in specific zip codes. She then sent a single beautifully designed watercolor card to seventy to one hundred addresses each month. Her return was an average of 3 percent every month. She also created a display of her work, which was hung in a local medical building. The school charity auctions were also a great source of advertising and branding for her name.

Judy's clientele is about 40 percent return customers because of the original baby program, which has enabled her to build a relationship with her customers and almost become one of the family. "It's a wonderful way to do business. It's also a wonderful referral base," Judy shares.

Judy reports that her business changes constantly. She finds herself always looking to create new products to sell. "You can only own so many canvas portraits," she adds. Offering new products to your existing client base helps you test the water. Judy always asks for feedback and wants to know what other products her clients may like. She also makes it a point to attend seminars, workshops, and conventions to gain insight into what's new in the market.

▶ **PROFESSIONAL REFLECTION**

"Looking for a novel marketing strategy, I designed a baby program for my clientele."

—Judy Host

INDEX

POSING AND LIGHTING TECHNIQUES FOR STUDIO PHOTOGRAPHERS

J. J. Allen

Master the skills you need to create beautiful lighting for portraits. Posing techniques for flattering, classic images help turn every portrait into a work of art. $34.95 list, 8.5x11, 120p, 125 color photos, order no. 1697.

CORRECTIVE LIGHTING, POSING & RETOUCHING FOR DIGITAL PORTRAIT PHOTOGRAPHERS, 2nd Ed.

Jeff Smith

Learn to make every client look his or her best by using lighting and posing to conceal real or imagined flaws—from baldness, to acne, to figure flaws. $34.95 list, 8.5x11, 120p, 150 color photos, order no. 1711.

PORTRAIT PHOTOGRAPHER'S HANDBOOK, 3rd Ed.

Bill Hurter

A step-by-step guide that easily leads the reader through all phases of portrait photography. This book will be an asset to experienced photographers and beginners alike. $34.95 list, 8.5x11, 128p, 175 color photos, order no. 1844.

PROFESSIONAL TECHNIQUES FOR DIGITAL WEDDING PHOTOGRAPHY, 2nd Ed.

Jeff Hawkins and Kathleen Hawkins

From selecting equipment, to marketing, to building a digital workflow, this book teaches how to make digital work for you. $34.95 list, 8.5x11, 128p, 85 color images, order no. 1735.

LIGHTING TECHNIQUES FOR HIGH KEY PORTRAIT PHOTOGRAPHY

Norman Phillips

Learn to meet the challenges of high key portrait photography and produce images your clients will adore. $34.95 list, 8.5x11, 128p, 100 color

MASTER POSING GUIDE FOR PORTRAIT PHOTOGRAPHERS

J. D. Wacker

Learn the techniques you need to pose single portrait subjects, couples, and groups for studio or location portraits. Includes techniques for photographing weddings, teams, children, special events, and much more. $34.95 list, 8.5x11, 128p, 80 photos, order no. 1722.photos, order no. 1736.

LIGHTING TECHNIQUES FOR LOW KEY PORTRAIT PHOTOGRAPHY

Norman Phillips

Learn to create the dark tones and dramatic lighting that typify this classic portrait style. $34.95 list, 8.5x11, 128p, 100 color photos, index, order no. 1773.

THE DIGITAL DARKROOM GUIDE WITH ADOBE® PHOTOSHOP®

Maurice Hamilton

Bring the skills and control of the photographic darkroom to your desktop with this complete manual. $29.95 list, 8.5x11, 128p, 140 color images, index, order no. 1775.

COLOR CORRECTION AND ENHANCEMENT WITH ADOBE® PHOTOSHOP®

Michelle Perkins

Master precision color correction and artistic color enhancement techniques for scanned and digital photos. $29.95 list, 8.5x11, 128p, 300 color images, index, order no. 1776.

FANTASY PORTRAIT PHOTOGRAPHY

Kimarie Richardson

Learn how to create stunning portraits with fantasy themes—from fairies and angels, to 1940s glamour shots. Includes portrait ideas for infants through adults. $29.95 list, 8.5x11, 128p, 60 color photos index, order no. 1777.

BEGINNER'S GUIDE TO PHOTOGRAPHIC LIGHTING

Don Marr

Create high-impact photographs of any subject with Marr's simple techniques. From edgy and dynamic to subdued and natural, this book will show you how to get the myriad effects you're after. $34.95 list, 8.5x11, 128p, 150 color photos, index, order no. 1785.

BEGINNER'S GUIDE TO ADOBE® PHOTOSHOP®, 3rd Ed.

Michelle Perkins

Enhance your photos or add unique effects to any image. Short, easy-to-digest lessons will boost your confidence and ensure outstanding images. $34.95 list, 8.5x11, 128p, 80 color images, 120 screen shots, order no. 1823.

POSING FOR PORTRAIT PHOTOGRAPHY

A HEAD-TO-TOE GUIDE

Jeff Smith

Author Jeff Smith teaches surefire techniques for fine-tuning every aspect of the pose for the most flattering results. $34.95 list, 8.5x11, 128p, 150 color photos, index, order no. 1786.

PROFESSIONAL MODEL PORTFOLIOS

A STEP-BY-STEP GUIDE FOR PHOTOGRAPHERS

Billy Pegram

Learn to create portfolios that will get your clients noticed—and hired! $34.95 list, 8.5x11, 128p, 100 color images, index, order no. 1789.

THE PORTRAIT PHOTOGRAPHER'S GUIDE TO POSING

Bill Hurter

Posing can make or break an image. Now you can get the posing tips and techniques that have propelled the finest portrait photographers in the industry to the top. $34.95 list, 8.5x11, 128p, 200 color photos, index, order no. 1779.

MASTER LIGHTING GUIDE

FOR PORTRAIT PHOTOGRAPHERS

Christopher Grey

Efficiently light executive and model portraits, high and low key images, and more. Master traditional lighting styles and use creative modifications that will maximize your results. $29.95 list, 8.5x11, 128p, 300 color photos, index, order no. 1778.

STUDIO LIGHTING

A PRIMER FOR PHOTOGRAPHERS

Lou Jacobs Jr.

Get started in studio lighting. Jacobs outlines equipment needs, terminology, lighting setups and much more, showing you how to create top-notch portraits and still lifes. $29.95 list, 8.5x11, 128p, 190 color photos index, order no. 1787.

WEDDING AND PORTRAIT PHOTOGRAPHERS' LEGAL HANDBOOK

N. Phillips and C. Nudo, Esq.

Don't leave yourself exposed! Sample forms and practical discussions help you protect yourself and your business. $29.95 list, 8.5x11, 128p, 25 sample forms, index, order no. 1796.

MARKETING & SELLING TECHNIQUES

FOR DIGITAL PORTRAIT PHOTOGRAPHY

Kathleen Hawkins

Great portraits aren't enough to ensure the success of your business! Learn how to attract clients and boost your sales. $34.95 list, 8.5x11, 128p, 150 color photos, index, order no. 1804.

ARTISTIC TECHNIQUES WITH ADOBE® PHOTOSHOP® AND COREL® PAINTER®

Deborah Lynn Ferro

Flex your creativity and learn how to transform photographs into fine-art masterpieces. Step-by-step techniques make it easy! $34.95 list, 8.5x11, 128p, 200 color images, index, order no. 1806.

DIGITAL PHOTOGRAPHY BOOT CAMP

Kevin Kubota

Kevin Kubota's popular workshop is now a book! A down-and-dirty, step-by-step course in building a professional photography workflow and creating digital images that sell! $34.95 list, 8.5x11, 128p, 250 color images, index, order no. 1809.

PROFESSIONAL POSING TECHNIQUES FOR WEDDING AND PORTRAIT PHOTOGRAPHERS

Norman Phillips

Master the techniques you need to pose subjects successfully—whether you are working with men, women, children, or groups. $34.95 list, 8.5x11, 128p, 260 color photos, index, order no. 1810.

THE BEST OF FAMILY PORTRAIT PHOTOGRAPHY

Bill Hurter

Acclaimed photographers reveal the secrets behind their most successful family portraits. Packed with award-winning images and helpful techniques. $34.95 list, 8.5x11, 128p, 150 color photos, index, order no. 1812.

BLACK & WHITE PHOTOGRAPHY
TECHNIQUES WITH ADOBE® PHOTOSHOP®

Maurice Hamilton

Become a master of the black & white digital darkroom! Covers all the skills required to perfect your black & white images and produce dazzling fine-art prints. $34.95 list, 8.5x11, 128p, 150 color/b&w images, index, order no. 1813.

PROFESSIONAL MARKETING & SELLING TECHNIQUES FOR DIGITAL WEDDING PHOTOGRAPHERS
2nd Ed.

Jeff Hawkins and Kathleen Hawkins

Taking great photos isn't enough to ensure success! Become a master marketer and salesperson with these easy techniques. $34.95 list, 8.5x11, 128p, 150 color photos, index, order no. 1815.

MASTER COMPOSITION GUIDE FOR DIGITAL PHOTOGRAPHERS

Ernst Wildi

Composition can truly make or break an image. Master photographer Ernst Wildi shows you how to analyze your scene or subject and produce the best-possible image. $34.95 list, 8.5x11, 128p, 150 color photos, index, order no. 1817.

THE BEST OF ADOBE® PHOTOSHOP®

Bill Hurter

Rangefinder editor Bill Hurter calls on the industry's top photographers to share their strategies for using Photoshop to intensify and sculpt their images. $34.95 list, 8.5x11, 128p, 170 color photos, 10 screen shots, index, order no. 1818.

MASTER LIGHTING TECHNIQUES FOR OUTDOOR AND LOCATION DIGITAL PORTRAIT PHOTOGRAPHY

Stephen A. Dantzig

Use natural light alone or with flash fill, barebulb, and strobes to shoot perfect portraits all day long. $34.95 list, 8.5x11, 128p, 175 color photos, diagrams, index, order no. 1821.

THE BEST OF PROFESSIONAL DIGITAL PHOTOGRAPHY

Bill Hurter

Digital imaging has a stronghold on photography. This book spotlights the methods that today's photographers use to create their best images. $34.95 list, 8.5x11, 128p, 180 color photos, 20 screen shots, index, order no. 1824.

PROFESSIONAL PORTRAIT LIGHTING
TECHNIQUES AND IMAGES FROM MASTER PHOTOGRAPHERS

Michelle Perkins

Get a behind-the-scenes look at the lighting techniques employed by the world's top portrait photographers. $34.95 list, 8.5x11, 128p, 200 color photos, index, order no. 2000.

MASTER POSING GUIDE FOR CHILDREN'S PORTRAIT PHOTOGRAPHY

Norman Phillips

Create perfect portraits of infants, tots, kids, and teens. Includes techniques for standing, sitting, and floor poses for boys and girls, individuals, and groups. $34.95 list, 8.5x11, 128p, 305 color images, order no. 1826.

RANGEFINDER'S PROFESSIONAL PHOTOGRAPHY

edited by Bill Hurter

Editor Bill Hurter shares over one hundred "recipes" from *Rangefinder's* popular cookbook series, showing you how to shoot, pose, light, and edit fabulous images. $34.95 list, 8.5x11, 128p, 150 color photos, index, order no. 1828.

MASTER GUIDE FOR PROFESSIONAL PHOTOGRAPHERS

Patrick Rice

Turn your hobby into a thriving profession. This book covers equipment essentials, capture strategies, lighting, posing, digital effects, and more, providing a solid footing for a successful career. $34.95 list, 8.5x11, 128p, 200 color images, order no. 1830.

PROFESSIONAL FILTER TECHNIQUES FOR DIGITAL PHOTOGRAPHERS

Stan Sholik

Select the best filter options for your photographic style and discover how their use will affect your images. $34.95 list, 8.5x11, 128p, 150 color images, index, order no. 1831.

MASTER'S GUIDE TO WEDDING PHOTOGRAPHY
CAPTURING UNFORGETTABLE MOMENTS AND LASTING IMPRESSIONS

Marcus Bell

Learn to capture the unique energy and mood of each wedding and build a lifelong client relationship. $34.95 list, 8.5x11, 128p, 200 color photos, index, order no. 1832.

MASTER LIGHTING GUIDE
FOR COMMERCIAL PHOTOGRAPHERS

Robert Morrissey

Use the tools and techniques pros rely on to land corporate clients. Includes diagrams, images, and techniques for a failsafe approach for shots that sell. $34.95 list, 8.5x11, 128p, 110 color photos, 125 diagrams, index, order no. 1833.

DIGITAL CAPTURE AND WORKFLOW
FOR PROFESSIONAL PHOTOGRAPHERS

Tom Lee

Cut your image-processing time by fine-tuning your workflow. Includes tips for working with Photoshop and Adobe Bridge, plus framing, matting, and more. $34.95 list, 8.5x11, 128p, 150 color images, index, order no. 1835.

THE PHOTOGRAPHER'S GUIDE TO COLOR MANAGEMENT
PROFESSIONAL TECHNIQUES FOR CONSISTENT RESULTS

Phil Nelson

Learn how to keep color consistent from device to device, ensuring greater efficiency and more accurate results. $34.95 list, 8.5x11, 128p, 175 color photos, index, order no. 1838.

SOFTBOX LIGHTING TECHNIQUES
FOR PROFESSIONAL PHOTOGRAPHERS

Stephen A. Dantzig

Learn to use one of photography's most popular lighting devices to produce soft and flawless effects for portraits, product shots, and more. $34.95 list, 8.5x11, 128p, 260 color images, index, order no. 1839.

CHILDREN'S PORTRAIT PHOTOGRAPHY HANDBOOK

Bill Hurter

Packed with inside tips from industry leaders, this book shows you the ins and outs of working with some of photography's most challenging subjects. $34.95 list, 8.5x11, 128p, 175 color images, index, order no. 1840.

JEFF SMITH'S LIGHTING FOR OUTDOOR AND LOCATION PORTRAIT PHOTOGRAPHY

Learn how to use light throughout the day—indoors and out—and make location portraits a highly profitable venture for your studio. $34.95 list, 8.5x11, 128p, 170 color images, index, order no. 1841.

PROFESSIONAL CHILDREN'S PORTRAIT PHOTOGRAPHY

Lou Jacobs Jr.

Fifteen top photographers reveal their most successful techniques—from working with uncooperative kids, to lighting, to marketing your studio. $34.95 list, 8.5x11, 128p, 200 color photos, index, order no. 2001.

CHILDREN'S PORTRAIT PHOTOGRAPHY
A PHOTOJOURNALISTIC APPROACH

Kevin Newsome

Learn how to capture spirited images that reflect your young subject's unique personality and developmental stage. $34.95 list, 8.5x11, 128p, 150 color images, index, order no. 1843.

PROFESSIONAL PORTRAIT POSING
TECHNIQUES AND IMAGES FROM MASTER PHOTOGRAPHERS

Michelle Perkins

Learn how master photographers pose subjects to create unforgettable images. $34.95 list, 8.5x11, 128p, 175 color images, index, order no. 2002.

STUDIO PORTRAIT PHOTOGRAPHY OF CHILDREN AND BABIES, 3rd Ed.

Marilyn Sholin

Work with the youngest portrait clients to create cherished images. Includes techniques for working with kids at every developmental stage, from infant to preschooler. $34.95 list, 8.5x11, 128p, 140 color photos, order no. 1845.

MONTE ZUCKER'S PORTRAIT PHOTOGRAPHY HANDBOOK

Acclaimed portrait photographer Monte Zucker takes you behind the scenes and shows you how to create a "Monte Portrait." Covers techniques for both studio and location shoots. $34.95 list, 8.5x11, 128p, 200 color photos, index, order no. 1846.

DIGITAL PHOTOGRAPHY FOR CHILDREN'S AND FAMILY PORTRAITURE, 2nd Ed.

Kathleen Hawkins

Learn how staying on top of advances in digital photography can boost your sales and improve your artistry and workflow. $34.95 list, 8.5x11, 128p, 195 color images, index, order no. 1847.

LIGHTING AND POSING TECHNIQUES FOR PHOTOGRAPHING WOMEN

Norman Phillips

Make every female client look her very best. This book features tips from top pros and diagrams that will facilitate learning. $34.95 list, 8.5x11, 128p, 200 color images, index, order no. 1848.

THE BEST OF PHOTOGRAPHIC LIGHTING

2nd Ed.

Bill Hurter

Top pros reveal the secrets behind their studio, location, and outdoor lighting strategies. Packed with tips for portraits, still lifes, and more. $34.95 list, 8.5x11, 128p, 200 color photos, index, order no. 1849.

MASTER GUIDE FOR TEAM SPORTS PHOTOGRAPHY

James Williams

Learn how adding team sports photography to your repertoire can help you meet your financial goals. Includes technical, artistic, organizational, and business strategies. $34.95 list, 8.5x11, 128p, 120 color photos, index, order no. 1850.

JEFF SMITH'S POSING TECHNIQUES FOR LOCATION PORTRAIT PHOTOGRAPHY

Use architectural and natural elements to support the pose, maximize the flow of the session, and create refined, artful poses for individual subjects and groups—indoors or out. $34.95 list, 8.5x11, 128p, 150 color photos, index, order no. 1851.

MASTER LIGHTING GUIDE
FOR WEDDING PHOTOGRAPHERS

Bill Hurter

Capture perfect lighting quickly and easily at the ceremony and reception—indoors and out. Includes tips from the pros for lighting individuals, couples, and groups. $34.95 list, 8.5x11, 128p, 200 color photos, index, order no. 1852.

POSING TECHNIQUES FOR PHOTOGRAPHING MODEL PORTFOLIOS

Billy Pegram

Learn to evaluate your model and create flattering poses for fashion photos, catalog and editorial images, and more. $34.95 list, 8.5x11, 128p, 200 color images, index, order no. 1848.

BIG BUCKS SELLING YOUR PHOTOGRAPHY, 4th Ed.

Cliff Hollenbeck

Build a new business or revitalize an existing one with the comprehensive tips in this popular book. Includes twenty forms you can use for invoicing clients, collections, follow-ups, and more. $34.95 list, 8.5x11, 144p, resources, business forms, order no. 1856.

ILLUSTRATED DICTIONARY OF PHOTOGRAPHY

Barbara A. Lynch-Johnt & Michelle Perkins

Gain insight into camera and lighting equipment, accessories, technological advances, film and historic processes, famous photographers, artistic movements, and more with the concise descriptions in this illustrated book. $34.95 list, 8.5x11, 144p, 150 color images, index, order no. 1857.